Drawing
the Surface
of Dance

Drawing
the Surface
of Dance
A Biography
in Charts

Annie-B Parson

Wesleyan University Press
Middletown, Connecticut

For Molly

Contents

Stuff
An Essay

In the aftermath of a performance, choreography is a discarded thing, the paper in the gutter that looks like a dead bird and reminds you how complex the body of everything is.

Choreography is more perishable than dancing, and dance is more perishable than fruit.

When the choreography is finally performed and then the piece closes, I think to myself: Draw the nouns. The objects are the nouns in the piece. The dance material is the verbs. The dancers are the sentence constructors, and sometimes the subject, but not always.

The making of the charts of the work happens after the choreography becomes "a dance," after the dancers and the audience have at it. Post-post-post everyone else involved in the work, the choreographer (me) reclaims stolen property in some dingy bus station. Have you ever been there? It's a sordid affair to be sure.

The charts are indexical, a cataloguing of the materiality of the piece. The charts are an anti-vanishing, the un-evaporation of the work into the ether. They are the:

"I am still interested in elements here and want to regard them again." The charts are a reclaiming of real estate after moving away, a squatter's right.

Charts: a graphic digression, new works from old works: a folk song.

The shape of the chart is a new choreographic structure. The charts are their own dance piece where the proscenium stage is the horizon line of your eyes, and the floor is made of paper. The lighting is your desk lamp. The music is the sound of you.

When you go on a trip, and come home, there is a closure to putting everything away in your drawers. The drawings put the objects back in the drawers. They're the old card catalogues in the library. They reference decaying books in broken stacks in libraries that you walk to one morning, but now they're condos or something, you're not sure.

Drawing is paper as theater, manifesting these ideas once again in space, but this time in a two dimensional space, and in a driverless durational mode. Here's how duration works in drawing: The creation of the drawing is happening in real time, sometimes in an instant and other

times with great muscle and pain, a kind of slow motion. And the charts are structured to be viewed in quick time, a glancing. But, the lack of durational control for the reading of the drawing, from a choreographic stance, is freeing.

Look at the nature of the stuff in the work: its coloration, its texture, its architecture, and most importantly the repetition of ideas from piece to piece. You can count the number of times sticks appear in each piece and then see that idea glide from work to work, as if sticks can never be exhausted, because of the nature of Mother Nature. You may note the repetition of placing microphones in objects; this idea was sewn into many of the earlier works, and then vanishes. Slippers appear over and over again, as do dots: snow, water, smoke, petals.

What is missing in the charts, what endures.

Please note: the introduction of furry things in 1999 and then the falling away of them by 2010. Please note: the introduction of things that light up in 1993 and disappearance of this motif by 2001. Surface matters.

Furry matters. Matters of slippage, matters of folding, matters that roll around, matters of the emanation of sound. Matters of things falling, dropping, floating. Matters of materiality, and its spirit. These things matter to me. Matter matters.

Objects are animate. Objects hold messages from other planes of consciousness. Be careful of those objects!

The [object] sang. The [object] sat next to her facing the same direction. The [object] went on a daredevil ride. The [object] rotated like the dancer. The [object] fell and splattered all over the floor and made a mess. The [object] flirted with the {object). The {object} sat still, meditating.

Annie-B Parson

1

Charts of
Works
1991–2018

Sacrifice, 1991

Pre-Big Dance Theater, this was the first of the many large-scale dance/theater works I made. The piece, as I vaguely remember it, was concerned with feminism and brides, Americana, kitsch imagery, and the start of a long-standing fascination with the properties, promises, and assumptions of the iconic red velvet curtain.

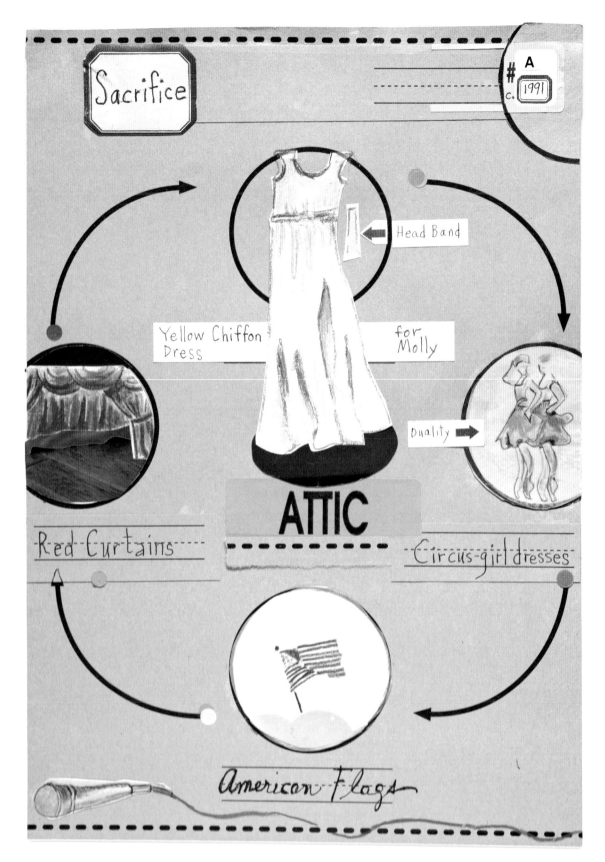

Sacrifice

A
c. 1991

Head Band

Yellow Chiffon Dress

for Molly

Duality →

ATTIC

Red Curtains

Circus-girl dresses

American Flags

13

Based on the dry, ironic and moving short story of the same name by Gustave Flaubert, with two dancers dancing the role of the protagonist simultaneously. An early exploration into compositional notions around complex symmetries, reverse mirroring, and duality.

A SIMPLE HEART
GUSTAVE FLAUBERT

A Simple

I

For half a century the women of Pont-l'Évêque envied Mme Aubain her maidservant Félicité.

...of his appeared to be a proof ... all the more for it. Every ... him, and every night Théo-... orries and entreaties.

...going to the Prefecture him-self to make inquiries, and that he would come and tell her how matters stood the following Sunday, between eleven and midnight.

To Braid

Lulu

Molly

Stacy

To Rock

CLAPPING-MOTIF

To Fold

To Clap

PIE

PIE

Another Telepathic Thing, 2000

Based on both Mark Twain's *Mysterious Stranger* and illicitly taped audio from Paul Lazar's movie auditions,[1] we combined two very disparate sources to talk about despair and aspiration, the after-life and magic. Big Dance made the piece at and for Dance Theater Workshop, and later it was made into a film by Jonathan Demme.

1. PAUL: Good morning kitty!
CASTING DIRECTOR: Good morning Paul. This is Chase. (gesturing to the cat)
PAUL: Chase—good name for a cat.
CASTING DIRECTOR: So, Paul? (gesturing to the costume he is wearing)
PAUL: This is from an ah—an ah—an anoth—another
CASTING DIRECTOR: Ouch! Stop it! (moving the cat away)
PAUL: —thing.
CASTING DIRECTOR: Chase is getting into this feisty stage. His canines are fully developed or virtually fully developed. And his sexual awareness is... so it's very low key, like all of your best work.

PAUL: I agree with you!
CASTING DIRECTOR: And we want you to have this passion, this particular passion. Um. Um. And... umm
PAUL: Gotcha.
CASTING DIRECTOR: Go to the script?
PAUL: "It was in 1590—winter. Austria was far away from the world, and asleep...I remember it well, although I was only a boy; and I remember, too, the pleasure it gave me. It drowsed in peace in the deep privacy of a hilly and woodsy solitude where new of the world hardly ever came to disturb its dreams and was infinitely content."

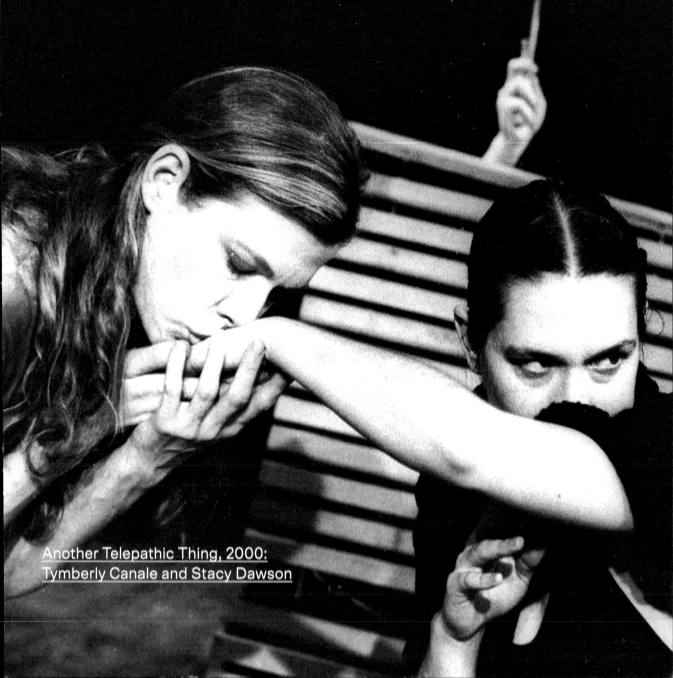

Another Telepathic Thing, 2000:
Tymberly Canale and Stacy Dawson

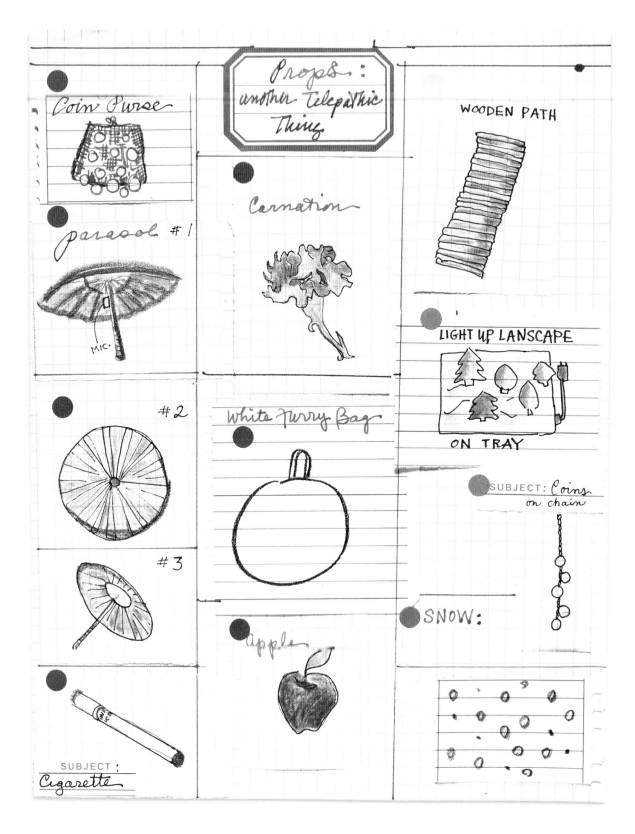

Coin Purse

Props :
another Telepathic
Thing

WOODEN PATH

Carnation

parasol #1

MIC.

#2

White Furry Bag

LIGHT UP LANSCAPE

ON TRAY

SUBJECT: Coins
on chain

#3

SNOW:

apple

SUBJECT :
Cigarette

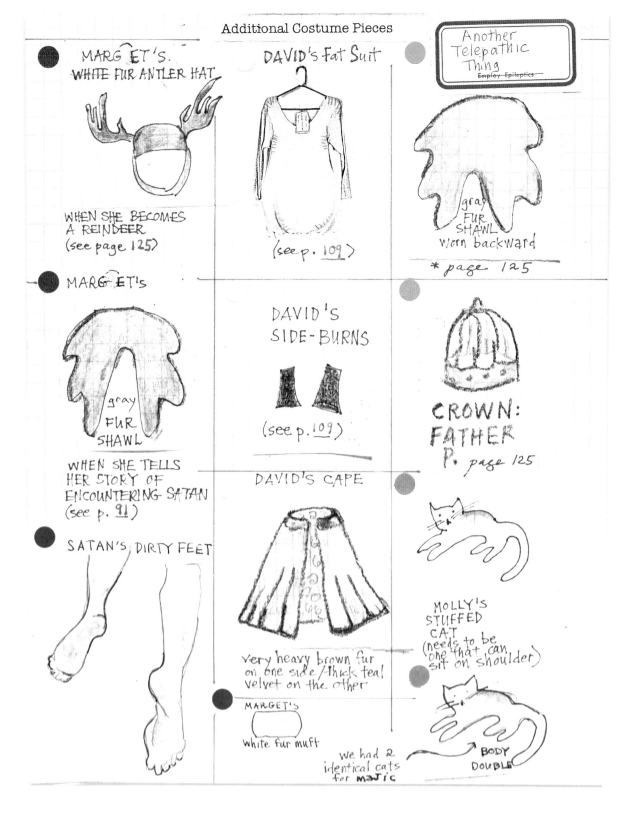

MARGÊT'S WHITE FUR ANTLER HAT

WHEN SHE BECOMES A REINDEER (see page 125)

DAVID's Fat Suit

(see p. 109)

Another Telepathic Thing
Employ Epileptics

gray FUR SHAWL worn backward

* page 125

MARGÊT'S

gray FUR SHAWL

WHEN SHE TELLS HER STORY OF ENCOUNTERING SATAN (see p. 91)

DAVID'S SIDE-BURNS

(see p. 109)

CROWN: FATHER P. page 125

SATAN'S DIRTY FEET

DAVID'S CAPE

very heavy brown fur on one side / thick teal velvet on the other

MARGET'S

white fur muft

MOLLY'S STUFFED CAT (needs to be one that can sit on shoulder)

BODY DOUBLE

we had 2 identical cats for majic

19

Commissioned by Japan Society, this piece is based loosely on a short story by the early 20th C. novelist Masuji Ibuse. To bring it to our own world we conflated his writing with inspirational speeches by American life-insurance salesmen, set to live Okinawan pop music. Dragging the past into the present continues to be a subject matter in my choreographies; I feel that we hold our past(s) deeply in our bodies, and I want to show that on stage. Dance curator David White described our work as "historically promiscuous," and, like most of the work of Big Dance, this one is roundly a-historic. Created with Paul Lazar and the Company.

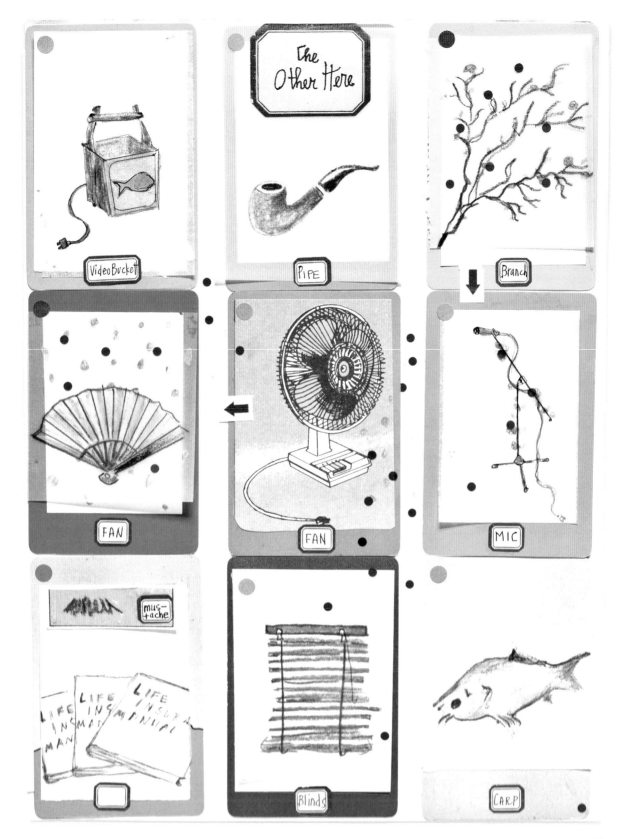

The Snow Falls in The Winter, 2008/2015

Based loosely on the language and tone of the absurdist play, *The Lesson* by Ionesco, a student enters a tutor's home and encounters a woman playing a man playing a bush moving in reverse. Ionesco is upended here, excavated solely for his flat tonality, his simple sentences and his stage directions. The subject matter of the piece became about learning and studying, in recognition of the tremendous amount of their lives dancers spend in class.

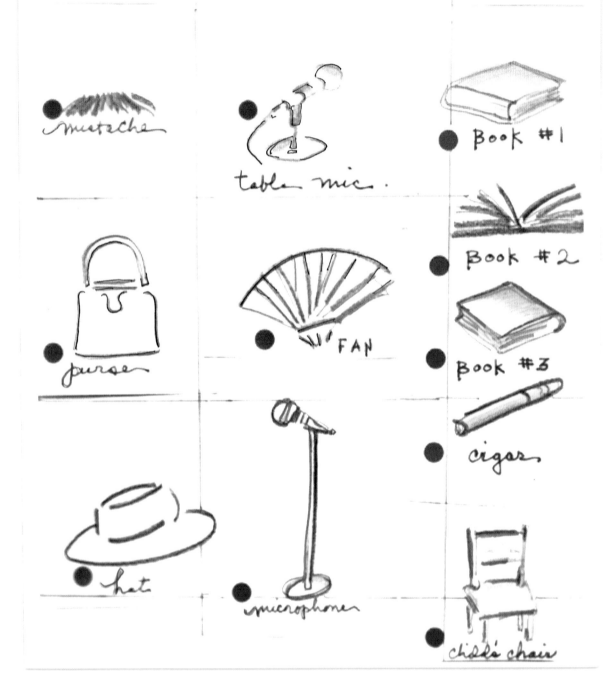

mustache

table mic.

Book #1

purse

FAN

Book #2

Book #3

hat

microphone

cigar

child's chair

A favorite Big Dance piece, created by re-purposing a screenplay by Agnes Varda.[2] I intentionally did not watch her film, but instead used the script as a map for a dance/theater work. A formal investigation on the intersection of film and theater, created about and in Lyon, France, at Les Subsistances.

2. FORTUNE TELLER: Cut miss and pick nine cards
CLEO: I know: three for the past, three for the present, and three for the future.
FORTUNE TELLER: (reading cards) There's a sickness in you.
CLEO: I knew it! It's serious isn't it?
FORTUNE TELLER: Yes, it's serious, but we mustn't exaggerate things. Pick another card.
CLEO: Enough! Keep quiet! I've known it for two days.
FORTUNE TELLER: Come now! You musn't cry! What will my clients who are waiting think? I'm not a bird of ill omen!

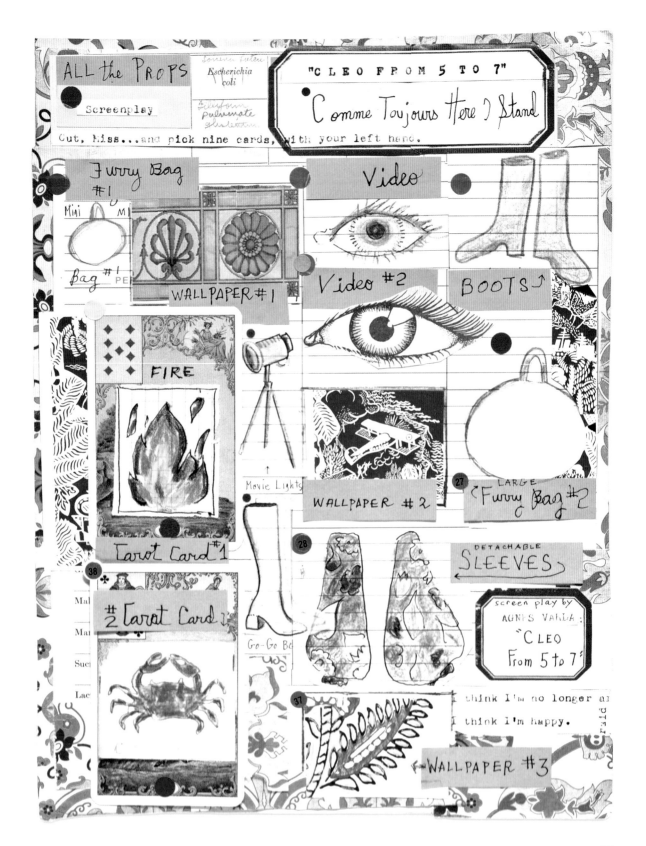

ALL the PROPS

Escherichia coli

Siliquum pulvinate glabosum

Screenplay

"CLEO FROM 5 TO 7"

Comme Toujours Here Stand

Cut, Miss...and pick nine cards, with your left hand.

Furry Bag #1

Video

Mini M

Bag #1 PE

WALLPAPER #1

Video #2

BOOTS ↑

FIRE

Movie Lights

Video

WALLPAPER #2

27 LARGE
Furry Bag #2

Tarot Card #1

28

DETACHABLE
SLEEVES →

38

screen play by
AGNES VARDA
"CLEO
From 5 to 7"

#2 Tarot Card

Mal
Mar
Such
Lac

Go-Go Bo

37

I think I'm no longer a

I think I'm happy.

WALLPAPER #3

Supernatural Wife, 2010

Co-created with Paul Lazar and based on a skeletal edit of the Anne Carson translation of Euripides' play *Alcestis*.[3] Euripides' ironic and emotional play begins with a woman sacrificing her life for her husband—and ends with her eerily returning from the dead. The play is simply the deepest writing I have ever read about grief and regret and is the most personally resonant script I have worked with. I came to feel that I knew Euripides as a human being. It is strange and thrilling to feel close to someone who lived thousands of years ago.

3. DEATH: Enter Admetos by back entrance toward front door of palace. ADMETOS: Put on black garments, Cut your hair, Cut the manes of your horses. Let there be no sound of the lyre for twelve full months For I shall never bury one who means more to me than this. She was the best. She died for me alone.

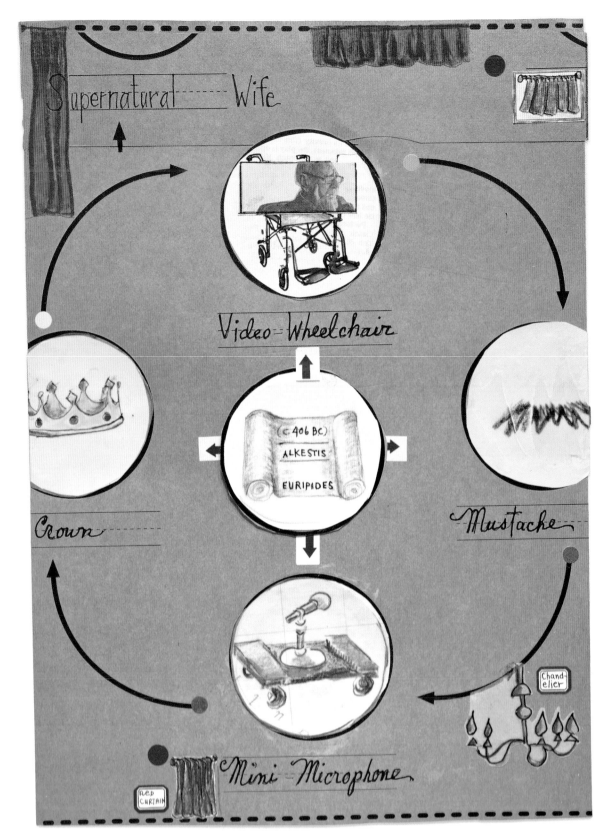

Supernatural - - - - - Wife

Video-Wheelchair

(c. 406 BC.)
ALKESTIS
EURIPIDES

Crown - - - - - - - - -

Mustache

Mini-Microphone

Chand-elier

RED CURTAIN

<u>Ich, Kürbisgeist, 2012</u>

A dance/play created from a script by Sibyl Kempson, written in an invented language.[4] Medieval in tone, full of strange rituals and brutal behaviors. Design by visual artists—costumes by Suzanne Bocanegra and set by Joanne Howard—are equally as important as the script or the choreography. Directed by Paul Lazar. Performed during Halloween in the basement of The Chocolate Factory during Hurricane Sandy for a tiny and intrepid audience. Looking back, we were all pretty sure our enacting of this play caused the storm, but we can't prove it.

4. TYMBL: Whr I crmt frm, it's an oold oold woods nr a field ond farming Oolder than Erper. Yin Ooldstre mumbers prvious tymes whn things wr ver diffrnt

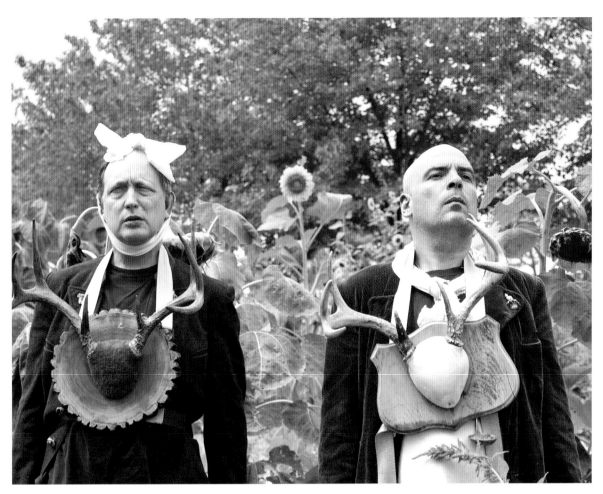

Ich, Kürbisgeist, 2012: Paul Lazar and Eric Dyer

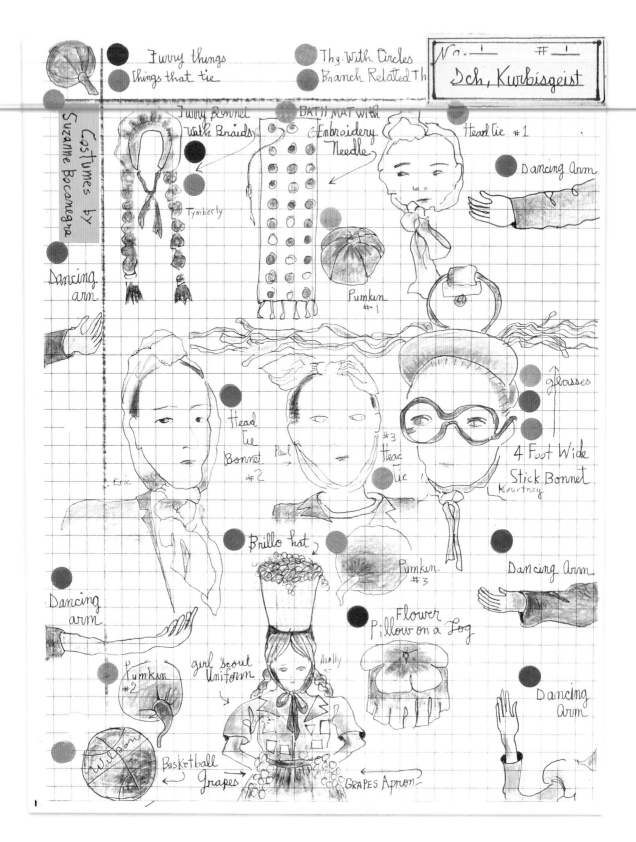

Furry Things
Things that tie
Thg. With Circles
Branch Related Th.

No. 1 # 1

Ich, Kurbisgeist

Costumes by Suzanne Bocanegra

Furry Bonnet With Braids

BATH MAT with Embroidery Needle

Head Tie # 1

Dancing Arm

Tymberly

Pumkin #1

Dancing arm

Head Tie Bonnet #2

Eric

Paul

#3 Head Tie

Kourtney

glasses

4 Foot Wide Stick Bonnet

Brillo hat

Pumkin #3

Dancing arm

Dancing arm

girl scout Uniform

Flower Pillow on a Log

Molly

Dancing arm

Pumkin #2

Wilson

Basketball Grapes

GRAPES Apron

PLAT No. 1

By Sybl kempson

31

<u>Here Lies Love, 2013</u>

A pop-eretta by David Byrne, the first musical that I have made dances for. I spent so many years working on *Here Lies Love* that at some point I made a chart of it. Though the elements and objects selected are not my own, they seeped into the choreography and became iconic in my mind.

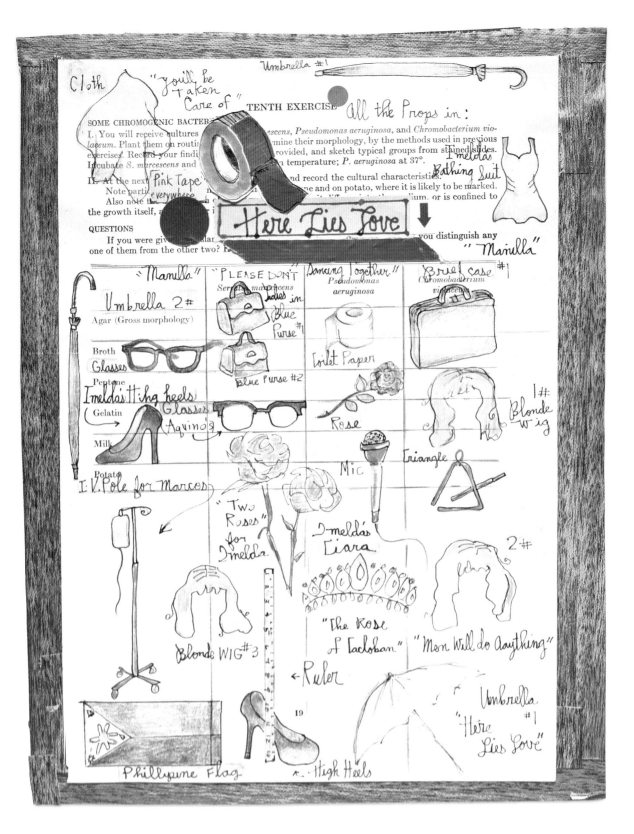

Umbrella #1

Cloth

"you'll be Taken Care of"

TENTH EXERCISE All the Props in:

SOME CHROMOGENIC BACTER... ...escens, *Pseudomonas aeruginosa*, and *Chromobacterium vio-*
I. You will receive cultures ...*laceum*. Plant them on routi... ...mine their morphology, by the methods used in previous
exercises. Record your findi... ...rovided, and sketch typical groups from stained slides.
Incubate *S. marcescens* andn temperature; *P. aeruginosa* at 37°.

Imelda's Bathing Suit

Pink Tape

II. At the nextnd record the cultural characteristics.
Note parti... everywhere ...ne and on potato, where it is likely to be marked.
Also note t... ...it di... ...dium, or is confined to
the growth itself,i

Here Lies Love

QUESTIONS
If you were giv... ...slar ...you distinguish any
one of them from the other two? ...

"Manilla"

"Manilla"	"PLEASE DON'T	"Dancing Together"	"Brief case #1
	Serratia marcescens	*Pseudomonas aeruginosa*	*Chromobacterium violaceum*
Umbrella 2# Agar (Gross morphology)	Ladies in Blue Purse #1		
Broth Glasses	Blue Purse #2	Toilet Paper	
Peptone Imelda's ↑↑ing heels			Blonde Wig 1#
Gelatin Glasses Aquino's	Glasses	Rose	
Milk		Mic	Triangle
Potato I.V. Pole for Marcos	"Two Roses" for Imelda	Imelda's Tiara	2#

Blonde WIG #3

"The Rose of Tacloban" "Men Will do Anything"

← Ruler

19

Umbrella #1 "Here Lies Love"

Philippine Flag

← High Heels

A very complicated piece that held narrative and abstraction as one, I rewrote the script of *Terms of Endearment* into multiple poetic forms.[5] Although I had employed poetics for choreographic structures, I had never used them to repurpose text. Other sources included a very skeletal edit of *Dr. Zhivago.* Underlying the work was the simple structure of crossing the stage from one side to the other. Co-created with Paul Lazar.

5. FLAP: Great good news. I know what my topic and subject is. I have it all worked and figured out.
EMMA: Where have you been all night Flap?
FLAP: I fell asleep at the book lending library on that big sofa couch again.
EMMA: I'm on to you.
FLAP: I'm not doing or being or physicalizing anything.
EMMA: Yes, you are.
FLAP: I hate it when you Emma feel sad and unhappy. We go through this stage and phase every time you are pregnant and carrying a child in your uterus.
EMMA: Don't change the subject.

FLAP: What's the subject and topic?
EMMA: That I'm on to you.
FLAP: You are going to have to take and accept my word and perspective. You always get paranoid and untrusting in your first trimester and pregnancy. Okay. Just.

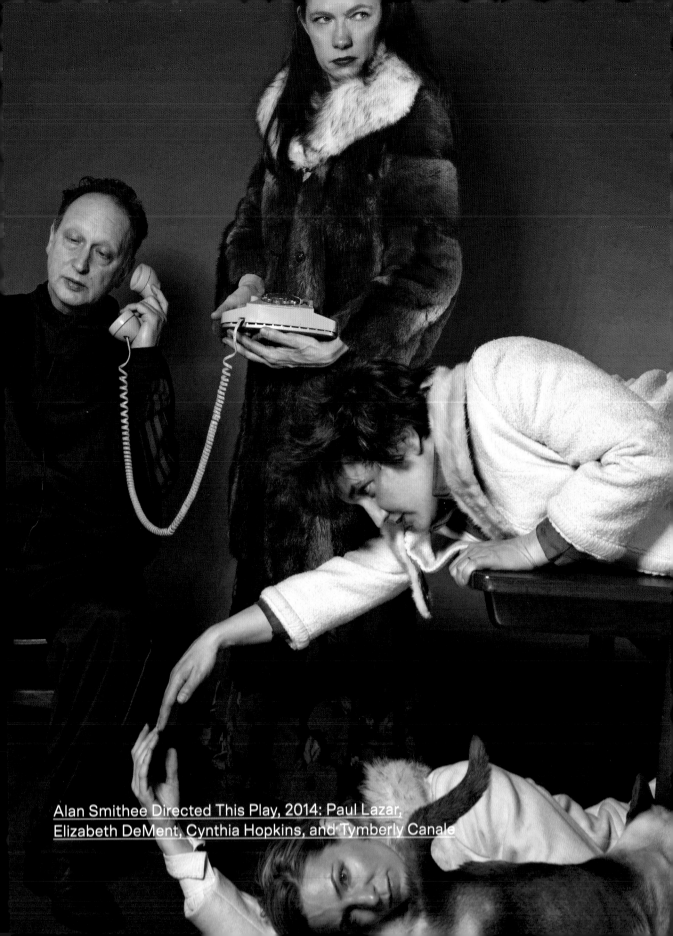

Alan Smithee Directed This Play, 2014: Paul Lazar, Elizabeth DeMent, Cynthia Hopkins, and Tymberly Canale

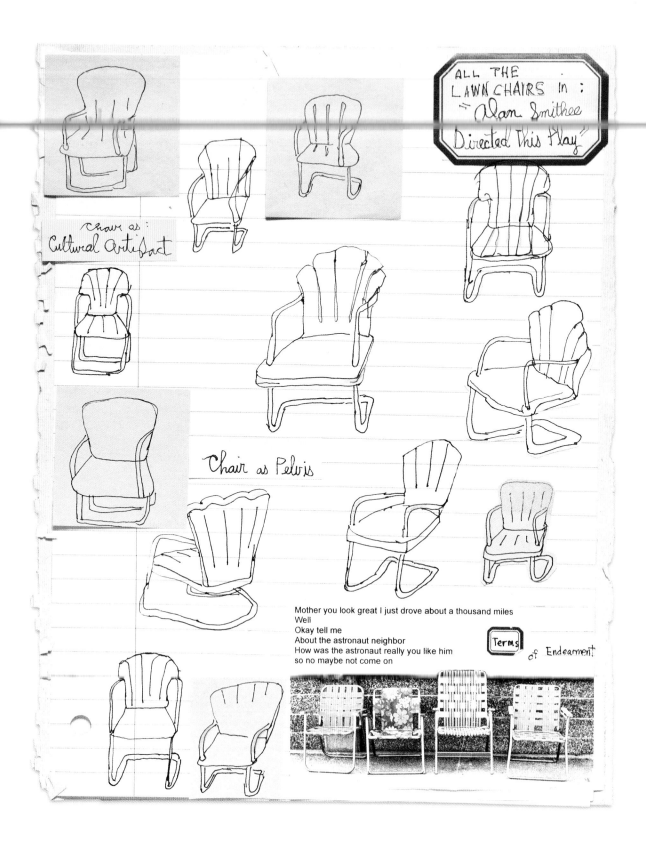

chair as:
Cultural Artifact

ALL THE LAWN CHAIRS in: "Alan Smithee Directed This Play"

Chair as Pelvis

Mother you look great I just drove about a thousand miles
Well
Okay tell me
About the astronaut neighbor
How was the astronaut really you like him
so no maybe not come on

Terms of Endearment

ALL the PROPS IN
IN
Alan Smithee
Directed This Play

Bandage

Lawn Chair +6

STICKS

Fur Coat +5

Phone +6

Brief case

X X X X X X X X X X

Gun

Short Ride Out, 2015

A solo concerned with factuality and unrelated actions
as content, and de-sequenced to free these actions
of any implied narrative. The beginnings of this solo
involved a slavish determination to "dance" all aspects
of a Stravinsky nocturne that I could perceive, and then
erase the music and leave the "erasure marks" of the
music for the audience to see in the dance, but not
hear. In this case, erasure marks would refer to rhythm,
tone, emotion, kinetics, tempo, and phrasing in the
original music. The music was eventually replaced with
a percussion work by Julia Wolfe for four hi-hat drums.
There are two *Short Ride Outs,* one female, danced by
Wendy Whelan at the Lynberry Theater/Royal Ballet
in London, and the other for Aaron Mattocks at the
Kitchen—the first cousin of Whelan's *Short Ride Out.*

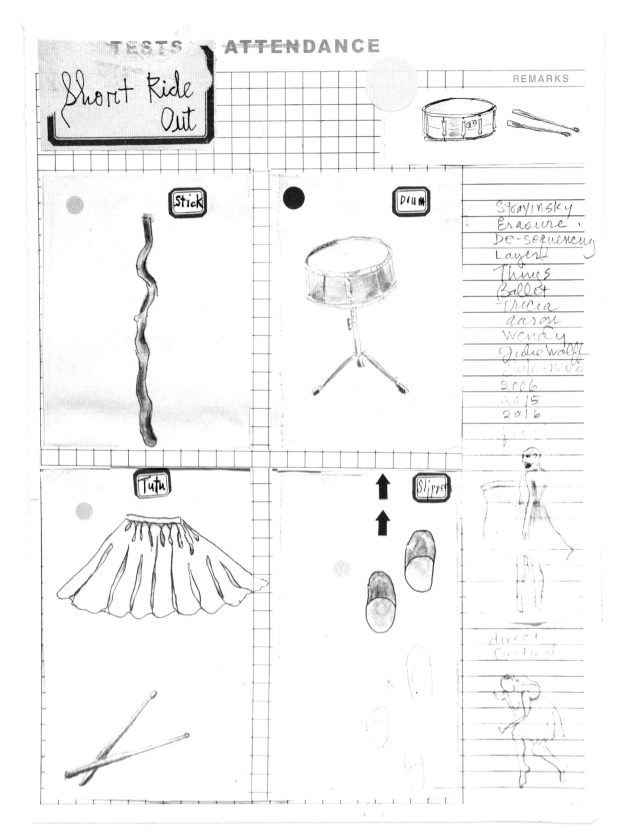

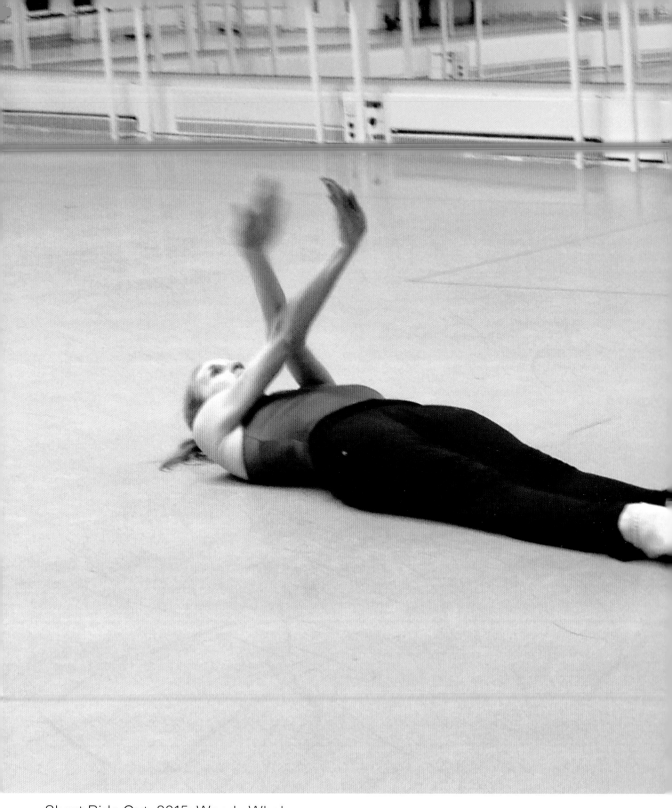

Short Ride Out, 2015: Wendy Whalen

Drawing the Surface of Dance Charts of Works

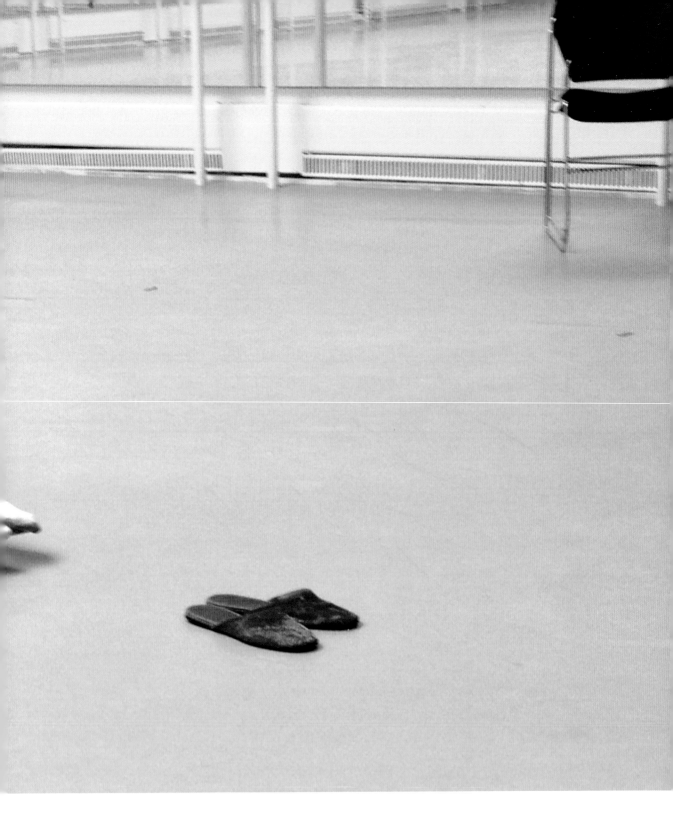

Directed by Ivo Van Hove to the music of David Bowie. I served solely as choreographer on this. But I drew a chart of it because the timing of Bowie's death, just after the premiere, made the play feel momentous. Bowie was a giant influence on performers and dance makers as well as musicians. At a time when many artists were paring down their statement by embracing the quotidian, he insisted on a deep theatricality with his saturated colors, his shape shifting identity, his makeup, and even his relationship to living on the planet itself. There was a perfect strangeness to his performance—he wasn't alienated; he was alien. And his dances: the specific abstraction, and the a-symbolic. I have an enduring image in my mind from an early album of his fingers held in an asymmetric shape to express messages from somewhere we don't know, have never been—a territory he always insisted on, claimed, and owned. The scale, the stratosphere of his music, reaches past the planet itself at times. He never claimed to be from here anyway.

ALL THE PROPS IN
LAZARUS

18 NOV — 17 JAN 2016

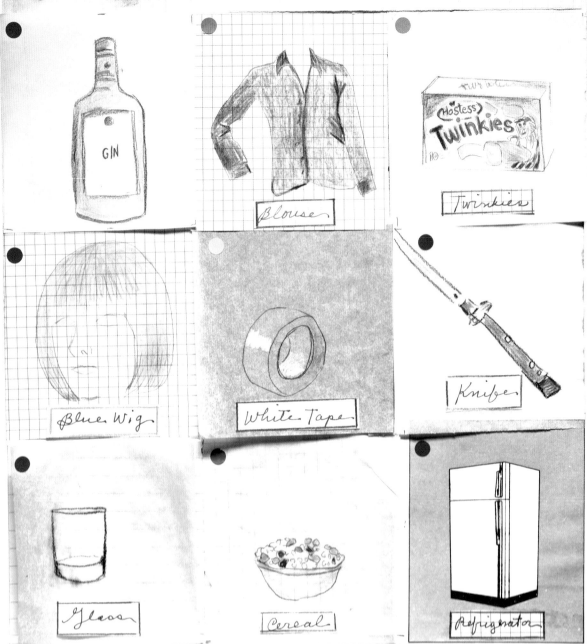

GIN

Blouse

Twinkies

Blue Wig

White Tape

Knife

Glass

Cereal

Refrigerator

An evening of short works in honor of Big Dance Theater's 25th anniversary. This show was an experiment in breaking the structure of the ubiquitous 75-minute long-form piece that I had been creating for many years; I was interested in how short pieces operate. Works included: *Short Ride Out, Goats,* and *Summer Forever.* In the middle was a 15-minute piece called *Intermission* where the audience came onstage, had a drink, a snack, and played some party games.

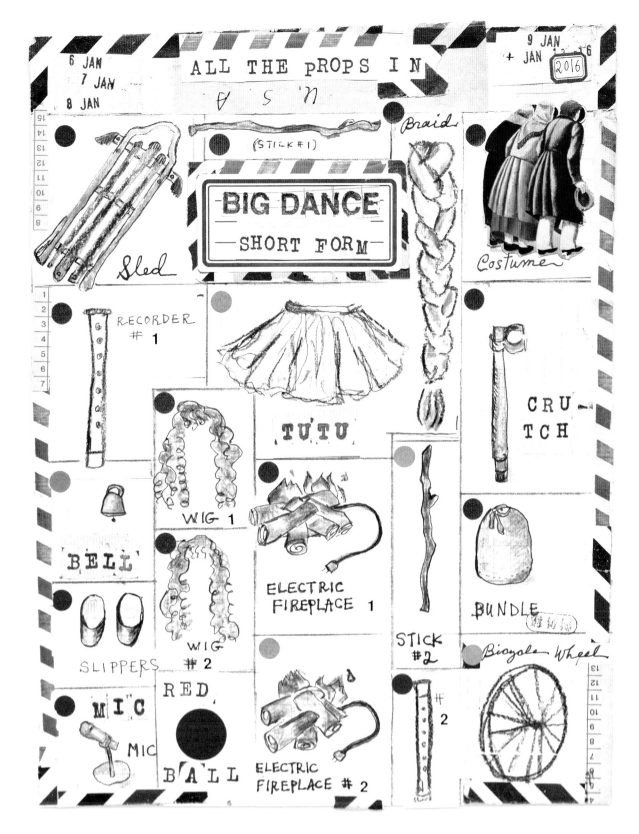

ALL THE pROPS IN A S N

6 JAN
7 JAN
8 JAN

9 JAN
+ JAN 2016

Sled

(STICK #1)

BIG DANCE
— SHORT FORM —

Braid

Costume

RECORDER # 1

TUTU

CRU-TCH

WIG 1

BELL

ELECTRIC FIREPLACE 1

STICK #2

BUNDLE

SLIPPERS

WIG #2

MIC

MIC

RED

BALL

ELECTRIC FIREPLACE #2

2

Bicycle Wheel

Air Guitar, 2017

A duet created for a corporate event for a rock musician in which I was charged to make a dance inspired by the iconic Italian 1980's design group, Memphis. Incorporating the designer's hot pink and teal chromatics and pop imagery, I choreographed a dance about the intuitive nature of friendship and duality, a subject that continues to interest me in the studio and in life.

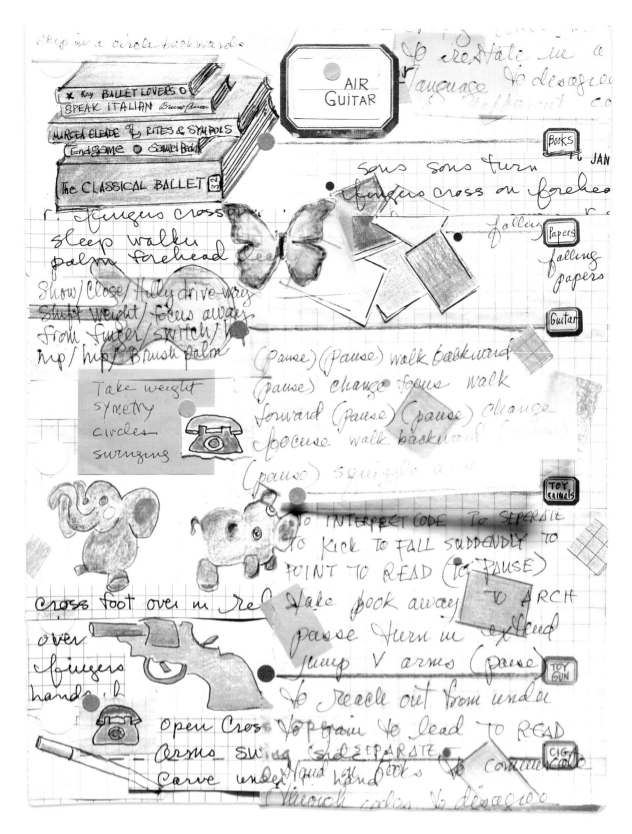

step in a circle backwards

AIR Guitar

To inestigate in a language To desagree

x Kay BALLET LOVERS O
SPEAK ITALIAN Bruno Munari
MIRCEA ELIADE & RITES & SYMBOLS
Endgame O Samuel Beckett
The CLASSICAL BALLET

BOOKS
JAN

sons sons turn
fingers cross on forehead

r. fingers cross
sleep walk
palm forehead
Show/Close/Hully drive-way
Shift weight/ focus away
from finger/ switch/
hip/ hip/ Brush palm

falling
Papers
falling
papers

Guitar

Take weight
symetry
circles
swinging

(pause)(Pause) walk backward
(pause) change focus walk
forward (pause)(pause) change
focuse walk backward
(pause) squiggle arm

TOY animals

TO INTERPRET CODE TO SEPERATE
To KICK TO FALL SUDDENLY TO
POINT TO READ (TO PAUSE)
Take book away TO ARCH
passe turn in extend
jump V arms (pause)

cross foot over in re

over
fingers
hands.

TOY GUN

To reach out from under

Open Cros To grain To lead TO READ
Arms swing side SEPARATE
Carve under grand hand books To continue
Through color To disagree

CIG

I created this piece for a company of elders at Sadler's Wells Theatre, London. The absurdist script *The Bald Soprano* by Ionesco felt appropriate in 2017, a year of sincere confusion and despair, and working with older dancers gave the work a darker feeling. Additionally, I added a brief version of the last scene from *The Cherry Orchard* to end the piece, for its elegiac tone and humor.[6] By projecting text on the back wall, I was able to include the audience in this scene; we were all in it together and that felt right. Using as few words as possible, I staged the piece as a birthday party for performers aged 70–90.

6. PAUL: Ah! Then goodbye, ladies and gentlemen.
MAID: So, you're off.
MR. SMITH: You know I loved you. I loved you. I'm a tender creature I am.
AUDIENCE: We should be going; there's very little time left.
MRS. SMITH: You look so old now. You don't do anything. You leave everything to fate.
MR. SMITH: But I love my millstone.
AUDIENCE: We must be going.
MAID: The winter will pass the spring will come.
AUDIENCE: Goodbye dear house!
MAID: These walls have seen so much.
MRS. SMITH: What are you looking for?
MR. SMITH: My galoshes.
AUDIENCE: Let's go. Let's go.
MAID: The sooner this is over, the sooner we can change our sad muddled lives.
AUDIENCE: You're on your way.
PAUL: Life in this house has come to an end; it's time to go.
AUDIENCE: The road awaits us. The road awaits us. The road awaits us.

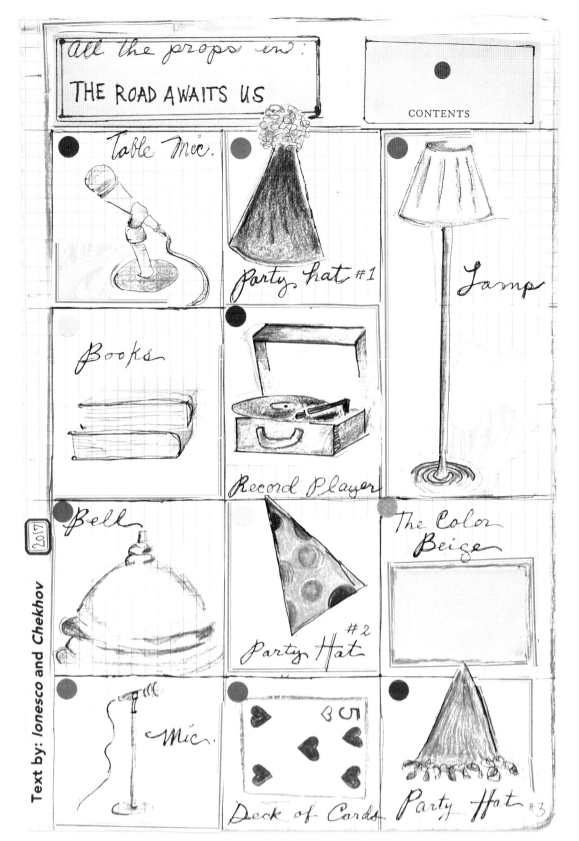

all the props in:

THE ROAD AWAITS US

CONTENTS

Table Mic.

Party hat #1

Lamp

Books

Record Player

Bell

Party Hat #2

The Color Beige

Mic.

Deck of Cards

Party Hat #3

Text by: Ionesco and Chekhov

2017

49

Cabinet Duet, 2017

Created as a duet for dancer Elizabeth DeMent and visual artist Mark Dion, based on his cabinet sculptures. Dion's work, like mine, is object-obsessed; we both believe in and manifest the secret lives of objects. Performed only once, at The Bard Center for Curatorial Studies.

Cabinet Duet, 2017: Elizabeth DeMent

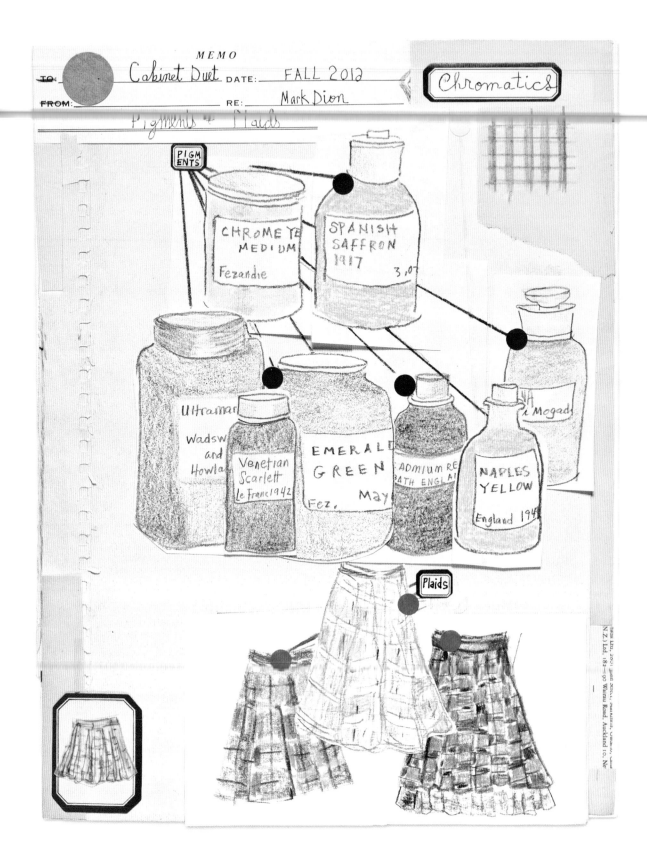

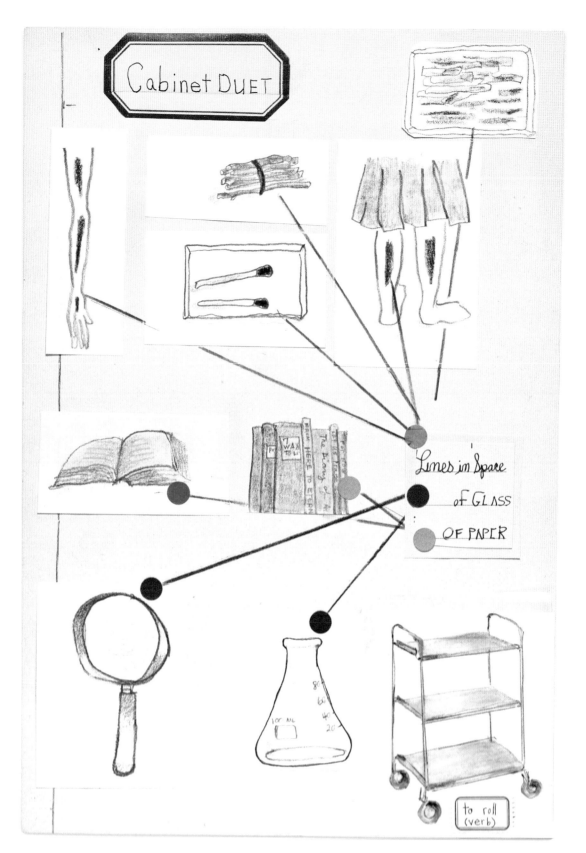

Cabinet DUET

Lines in Space
of GLASS
OF PAPER

to roll
(verb)

Big Dance Theater's raid on the uncensored, hyper-generative diaries of Samuel Pepys, the forgotten plays of radical feminist 17c writer Margaret Cavendish, and the erasure of Elizabeth Pepys.[7] Pepys' diaries reveal him as a Baroque hipster, who strode, strove, groped, climbed, dressed and danced his way through life—and wrote every bit of it down.

7. MC: What's your name?
LIZZIE: Elizabeth.
MC: And what role are you playing?
LIZZIE: Elizabeth.

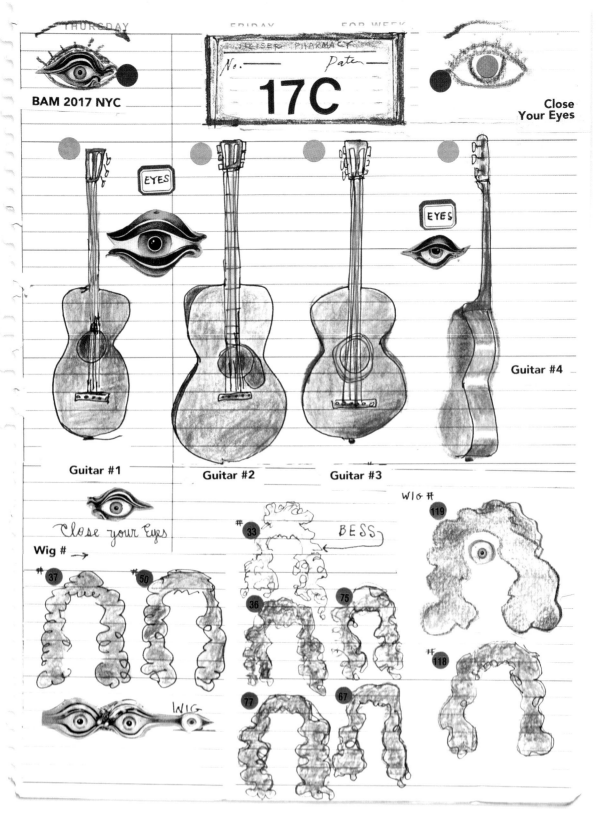

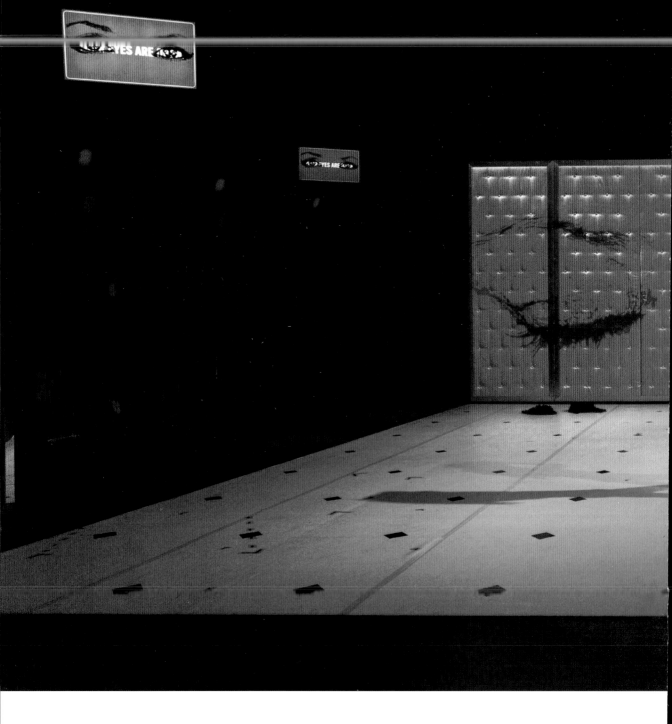

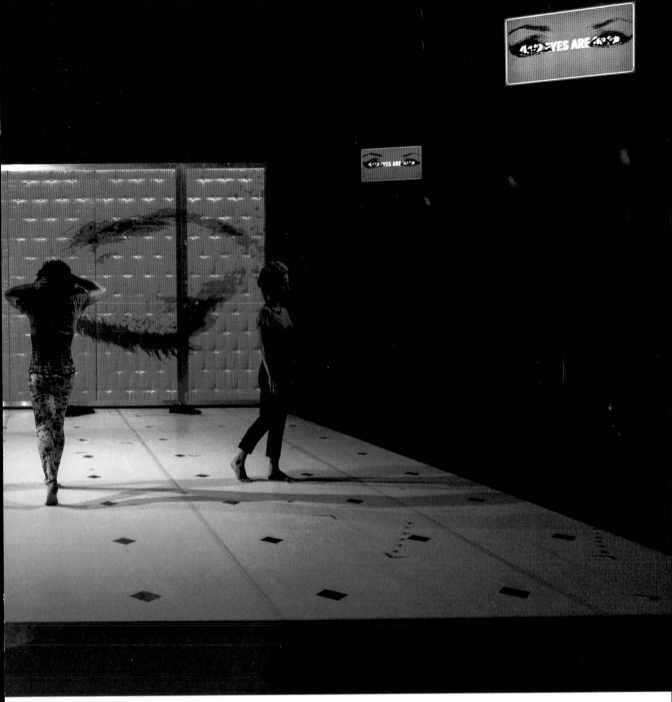

17c, 2017: Aaron Mattocks and Elizabeth DeMent

Created for The Martha Graham Dance Co., based on Graham's obscure work, *Punch and the Judy* (1941). I used the original work as a ghost in the room— my desire being to enter into dialogue with dance history via this rare piece of choreography. My intention was not to update the original, but instead to have a séance with it, interrogating the original work choreographically, musically, theatrically, and filmically. Repurposing the original footage and choreography, I both sampled and disrupted her dance, using distillation as my primary method. The original text was lost, so I asked Will Eno to write new text to be spoken into microphones.[8] The process—to go into deep conversation with Martha— proved revelatory.

8. FATE 1: Everything's back to normal.
FATE 2: No, it isn't. It can't be.
FATE 1: Look. They're returning to the dance they started, so many years ago.
FATE 2: They're not the same people. She practically died. He was in love, he leapt so high. Couldn't this end with a happy dance?
FATE 1: Or the husband could apologize. He could really truly apologize and let the wife know that he is afraid.
FATE 3: Or the wife could do a simple dance, just made out of different ways of standing still.

FATE 1: And she could say "I lived. I was lucky enough to live. I suffered. I was lucky enough to suffer. I'm gone. I'm lucky enough to be gone."

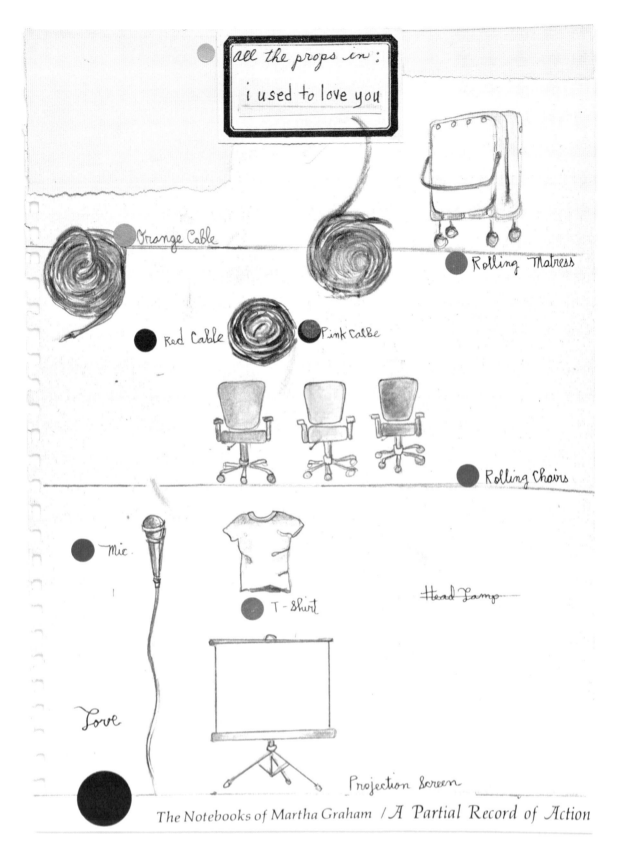

all the props in:

i used to love you

Orange Cable

Rolling Matress

Red Cable

Pink CalBe

Rolling Chairs

Mic.

T-Shirt

Head Lamp

Love

Projection Screen

The Notebooks of Martha Graham / A Partial Record of Action

A duet created in response to my lifelong obsession with ballet, particularly Balanchine's radically abstract *Agon* (1957). But/also, in response to the narrative ballets of the 19th C., for their insistence on wings, flowers, the color pink, floating, flying, and fairies appearing, toying with our minds for a moment and then disappearing. Danced to a repurposing of Stravinsky, and a voice-over written by John Haskell from his book *The Complete Ballet.*[9] Created at The Center for Ballet and the Arts, NYC.

9. VOICE OVER: The Sylph appears to James and she glides up to him and points to the tears in her eyes. She's sad because their love is impossible. She would like to be human, to experience human emotions, and although she's excited by the idea of love, in her heart she's afraid. She begins by standing on the very points of her toes, becoming flirtatious, and when he sees her extending herself, he can't resist. She isn't just beautiful, she's beauty itself, and captivated by that beauty he reaches out to hold her, and once he has her in his arms, she disappears.

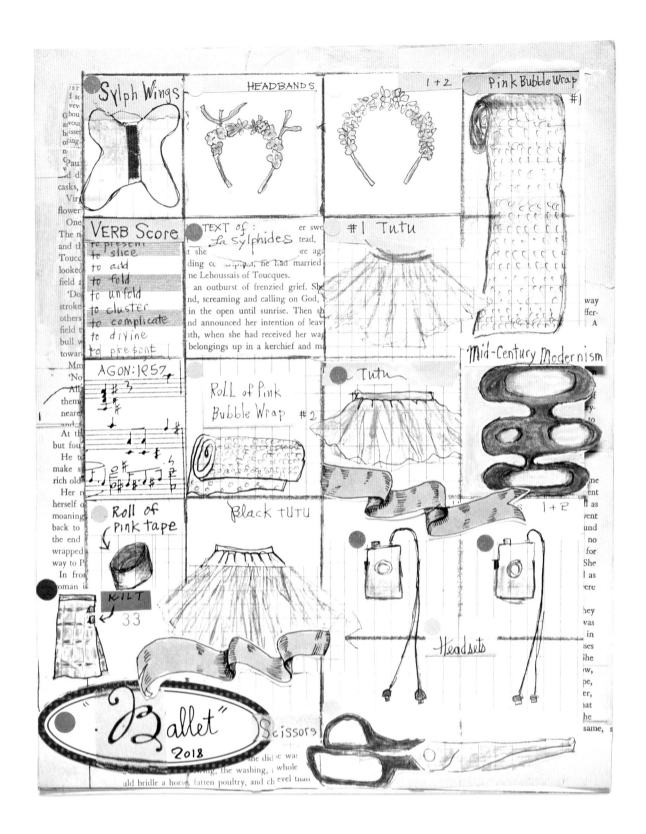

Sylph Wings

HEADBANDS

1 + 2

Pink Bubble Wrap #1

VERB Score

to present
to slice
to add
to fold
to unfold
to cluster
to complicate
to divine
to present

TEXT of: La Sylphides

#1 Tutu

AGON: 1957

Roll of Pink Bubble Wrap #2

Tutu

Mid-Century Modernism

1 + 2

Roll of Pink tape

KILT 33

Black TUTU

Headsets

"Ballet" 2018

Scissors

Antigonick, a philosophical and feminist adaptation of *Antigone,* written by Anne Carson about 2,500 years after Sophocles wrote his play—which itself was probably inspired by another folk tale of its kind—tells the eternally relevant story of a young woman who courageously confronts the King and the Law, knowing full well she will die for doing this. The intellectual excitement of the play lies in the argument itself, and why peaceful resistance matters.[10] Antigone risks her life simply because she wants her brother to receive a proper burial. The rights of the body in life and death are fundamental, organic, and continue to be fought for by women.

10. Verb: to resist

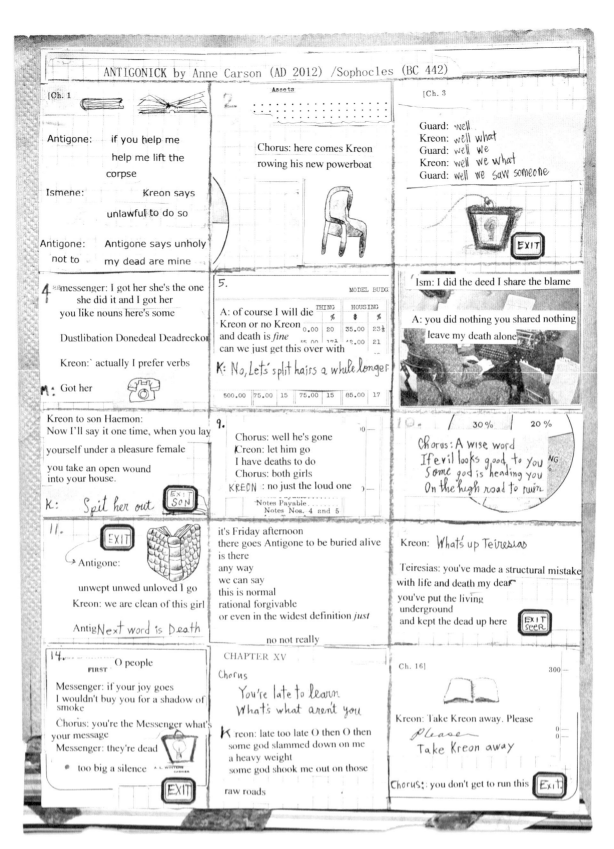

ANTIGONICK by Anne Carson (AD 2012) /Sophocles (BC 442)

[Ch. 1

Antigone: if you help me
help me lift the
corpse

Ismene: Kreon says
unlawful to do so

Antigone: Antigone says unholy
not to my dead are mine

2

Assets

Chorus: here comes Kreon
rowing his new powerboat

[Ch. 3

Guard: well
Kreon: well what
Guard: well we
Kreon: well we what
Guard: well we saw someone

EXIT

4 messenger: I got her she's the one
she did it and I got her
you like nouns here's some

Dustlibation Donedeal Deadreckon

Kreon: actually I prefer verbs

M: Got her

5.

MODEL BUDG.

A: of course I will die
Kreon or no Kreon
and death is *fine*
can we just get this over with

K: No, Let's split hairs a while longer

	THING		HOUSING			
	%	$	%			
	0.00	20	35.00	23½		
	75.00	17½	18.00	21		
500.00	75.00	15	75.00	15	85.00	17

Ism: I did the deed I share the blame

A: you did nothing you shared nothing
leave my death alone

Kreon to son Haemon:
Now I'll say it one time, when you lay

yourself under a pleasure female

you take an open wound
into your house.

K: Spit her out

EXIT SON

9.

Chorus: well he's gone
Kreon: let him go
I have deaths to do
Chorus: both girls
KREON: no just the loud one

Notes Payable.......
Notes Nos. 4 and 5

10.

30% 20%

Chorus: A wise word
If evil looks good to you
Some god is heading you
On the high road to ruin

11.

EXIT

Antigone:

unwept unwed unloved I go

Kreon: we are clean of this girl

Antig Next word is Death

it's Friday afternoon
there goes Antigone to be buried alive
is there
any way
we can say
this is normal
rational forgivable
or even in the widest definition *just*

no not really

Kreon: What's up Teiresias

Teiresias: you've made a structural mistake
with life and death my dear
you've put the living
underground
and kept the dead up here

EXIT SEER

14.
FIRST O people

Messenger: if your joy goes
I wouldn't buy you for a shadow of
smoke

Chorus: you're the Messenger what's
your message
Messenger: they're dead

• too big a silence

EXIT

CHAPTER XV

Chorus

You're late to learn
What's what aren't you

Kreon: late too late O then O then
some god slammed down on me
a heavy weight
some god shook me out on those

raw roads

Ch. 16]

300

Kreon: Take Kreon away. Please
Please
Take Kreon away

Chorus: you don't get to run this Exit

Since I began making work, I have cast women as men—never as a send-up, or commented on, but as simply as possible—sort of anti-drag in style. I like the layering of gender and find that not only is it reverse-Classical theater (women were not onstage in Western theater until 1660), but also find that I hear the part more clearly when a woman does it. "Let a child play the emperor to avoid any deception."

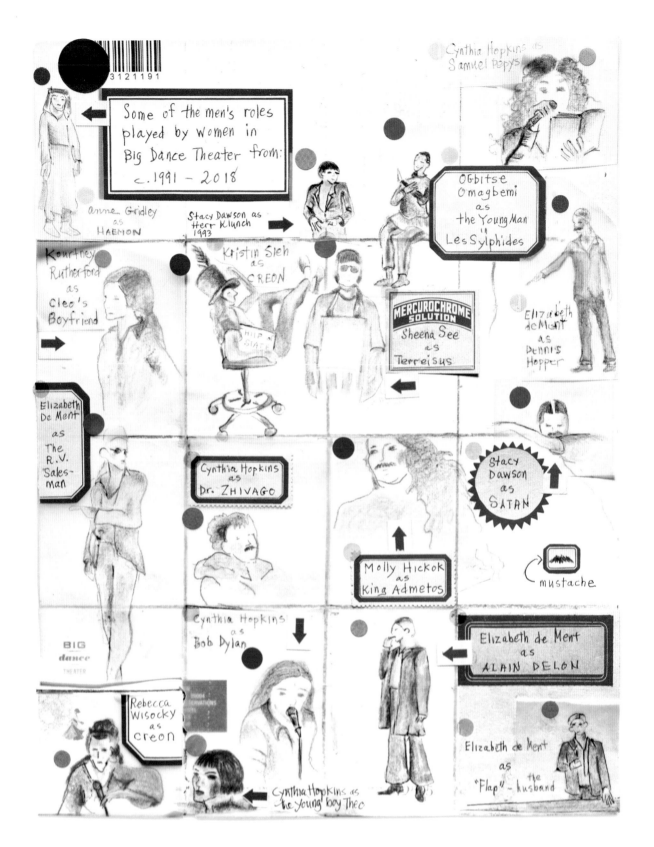

Some of the men's roles played by women in Big Dance Theater from: c.1991 – 2018

anne Gridley as HAEMON

Stacy Dawson as Herr Klunch 1993

Cynthia Hopkins as Samuel Pepys

Ogbitse Omagbemi as the Young Man in Les Sylphides

Kourtney Rutherford as Cleo's Boyfriend

Kristin Sieh as CREON

MERCUROCHROME SOLUTION
Sheena See as Terreisus

Elizabeth deMent as Dennis Hopper

Elizabeth De Ment as The R.V. 'Sales-man

Cynthia Hopkins as Dr. ZHIVAGO

Stacy Dawson as SATAN

Molly Hickok as King Admetos

mustache

BIG dance THEATER

Cynthia Hopkins as Bob Dylan

Elizabeth de Ment as ALAIN DELON

Rebecca Wisocky as creon

Cynthia Hopkins as the young boy Theo

Elizabeth de Ment as the "Flap" - husband

2

Structures
and Scores

A beloved object and clothing piece used as much for its shape as for its implied narrative, appearing in my work since 1991, used both front and back, male and female, layered with other aprons, reaching back in history. Aprons are referenced for their iconic shape and implied story, as well as for their ease in quickly changing costume.

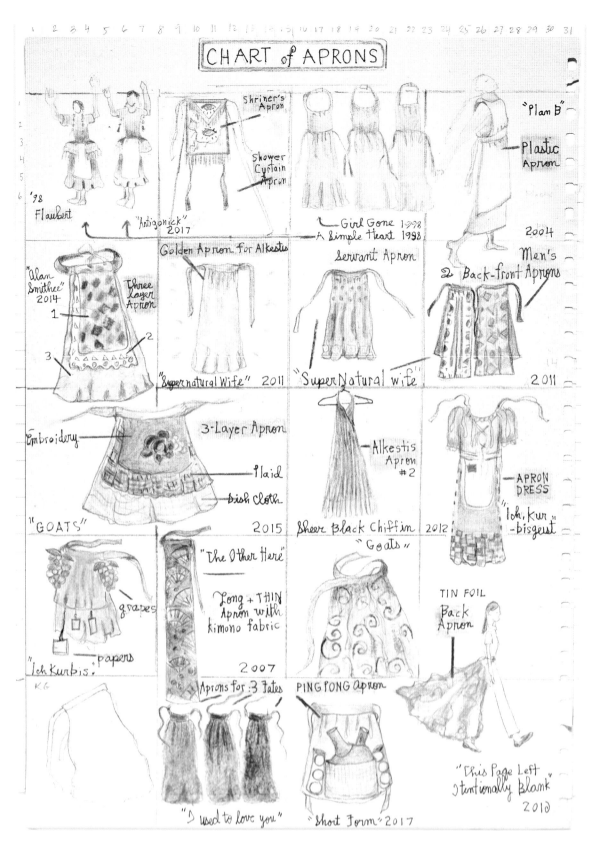

CHART of APRONS

1 2 3 4 5 6 7 8 9 10 11 12 13 14 15 16 17 18 19 20 21 22 23 24 25 26 27 28 29 30 31

'98 Flaubert

"Antigonick" 2017

Shriner's Apron

Shower Curtain Apron

Girl Gone 1998
A Simple Heart 1998

"Plan B"

Plastic Apron

2004

"Alan Smithee" 2014

Three Layer Apron

1
2
3

"Supernatural Wife" 2011

Golden Apron for Alkestis

Servant Apron

"SuperNatural wife"

Men's

2 Back-front Aprons

2011

Embroidery

3-Layer Apron

Plaid

Dish Cloth

"GOATS" 2015

Alkestis Apron #2

Sheer Black Chiffin
"Goats"

2012

APRON DRESS

"Ich. Kur" -bisgeist

grapes

papers

"Ich Kurbis."
K.G.

"The Other Here"

Long + THIN Apron with kimono fabric

2007

Aprons for 3 Fates

PING PONG apron

"I used to love you"

"Short Form" 2017

TIN FOIL Back Apron

"This Page Left Intentionally Blank"
2010

69

Chart of Braids

I think every piece I have made has someone in braids. I love that braids are both verbs and nouns; a compositional property, a reiterative structure in threes, and a hair-do. In the Greek dramas, I used complex braiding, as if there were messages in the patterning; in *Goats,* I sewed detachable braids on to the back of Heidi's costume to indicate a separation between character and dancer; in *A Simple Heart,* the two women playing the protagonist wore identical braids emphasizing their girlhood and their duality; in *The Other Here,* the servant wore a waist length grey braid to show her great age; in *Plan B,* the wild child wore a large long messy braid, never combed.
I charted many of the braids in my work, but I could not fit them all onto the page.

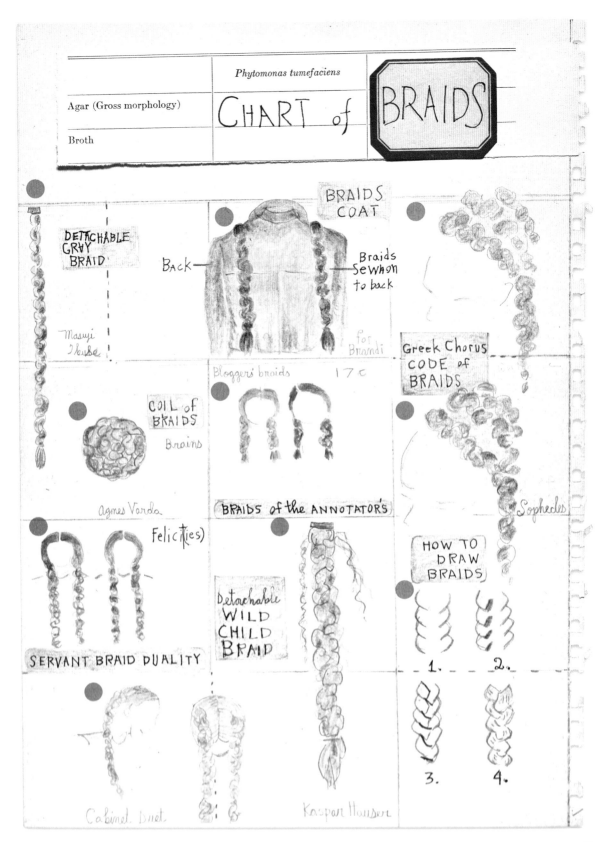

	Phytomonas tumefaciens	
Agar (Gross morphology)	CHART of	**BRAIDS**
Broth		

DETACHABLE GRAY BRAID

Masuyi Ibuse

BACK —

BRAIDS COAT

Braids sewn on to back

for Brandi

Greek Chorus CODE of BRAIDS

COIL of BRAIDS

Brains

Agnes Varda

Bloggers braids

17c

BRAIDS of the ANNOTATOR'S

Sophocles

Felicities)

SERVANT BRAID DUALITY

Detachable WILD CHILD BRAID

HOW TO DRAW BRAIDS

1. 2.

3. 4.

Cabinet bnet

Kaspar Hauser

Chart of Sticks

Sticks have continuously appeared in my work for their transformational properties: sticks as a compositional element; sticks as canes, as a symbol of the natural world, sticks as sticks, as decoration on a bonnet, as mic stands, as paths and fences— as lines in space. I am interested in visual and narrative relationships between art and nature; but also, in the relationship between art-making and nature. Art making is as natural as a leaf growing on a tree. Like plants we are generative because we are alive. And separating what we make from what nature makes is in error because it is one large system.

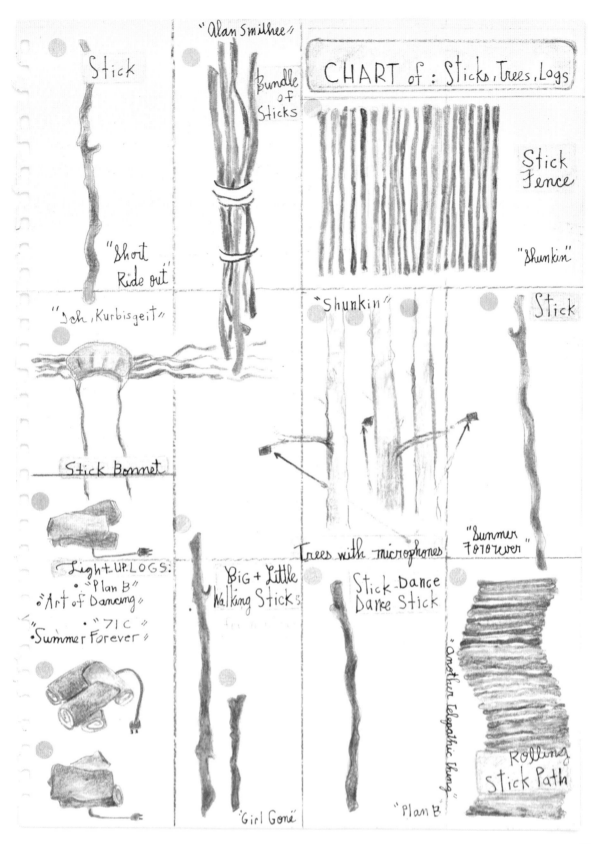

Stick

"Alan Smithee"

Bundle of Sticks

CHART of : Sticks, Trees, Logs

Stick Fence

"Short Ride out"

"Shunkin"

"Ich, Kurbisgeit"

"Shunkin"

Stick

Stick Bonnet

Trees with microphones

"Summer Fororever"

Light-UP-LOGS:
• "Plan B"
• "Art of Dancing"
• "71C"
• "Summer Forever"

Big + Little Walking Sticks

Stick-Dance Dance Stick

"Another telepathic thing"

"Girl Gone"

"Plan B"

Rolling Stick Path

Plan B, 2004: Tymberly Canale

Drawing the Surface of Dance Structures and Scores

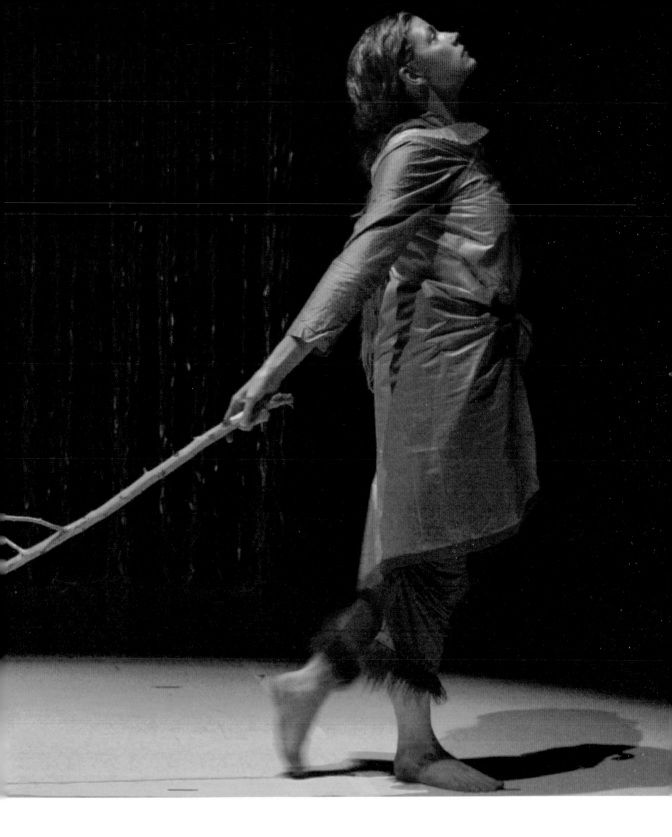

Chart of Things Circular

In praise of circularity and all things round in the dances I have made. From circle dancing, to the circle of the arms, to a basketball—the circle remains central to dance issues from the beginning of time. The shape of the circle emphasizes gathering together, wholeness and the deep connection between bodies, communities and objects in space. Here, in thinking compositionally, there is a natural loosening of the distinction between bodies/objects/floor patterns.

HALVORSON-ZIEGLER PROBABILITY TABLE*

Code		X	P		Code		X	P		Code		X	P			
10	10	10	100.0	100.0		10	10	0	2.40	3.4		10	9	0	1.70	5.30
10	10	9	25.0	58.7		10	10	0	6.07	0.01		10	8	7	3.10	0.01
10	10	8	10.2			10	9	8	5.26	0.01		10	8	6	2.78	0.14
10	10	7	12.0			10	9	7	4.58	0.27		10	8	5	2.49	0.56
10	10	6	9.7	25.0		10	9	6	3.98	0.85		10	8	4	2.21	1.64
10	10	5		24.2		10	9	5	3.46	2.25		10	8	3	1.96	4.50
10	10	4		.33		10	9	4	2.98	4.80		10	8	2	1.71	8.46
10	10		4.28	21.7		10	9	3	2.63	8.57		10	8	1	1.50	
10	10	2	3.49	17.3		10	9	2	2.28	11.77		10	8	0	1.30	
10	10	1	2.75	10.2		10	9	1	1.97	11.02		10	7	6	2.19	0.01
10	7	5		0.20		10	6			0.59		10	4	5	1.073	0.01
10	7	4		0.80		10	6	2	1.09	2.73		10	4	4	0.943	0.07
10	7	3		2.57		10	6	1	0.933			10	4	3	0.818	0.48
10	7	2	.33	6.17		10	6	0	0.792			10	4	2	0.700	2.26
10	7	1	1.16	10.01		10	5	5	1.30	0.02		10	4	1	0.589	7.97
10	7	0	1.01	9.33		10	5	4	1.15	0.14		10	4	0	0.493	14.99
10	6	6	1.75	0.01		10	5	3	1.02	0.91		10	3	4	0.773	0.02
10	6	5	1.57	0.08		10	5	2	0.872	3.30		10	3	3	0.662	0.24
10	6	4	1.41	0.11		10	5	1	0.742	8.94		10	3	2	0.561	1.60
10	6	3	1.25	0.59		10	5	0	0.622	12.68		10	3	1	0.474	6.93
10	3	0	.399	17.67		10	0	2	.314	0.15		9	5	1	.372	0.86
10	2	4	.631	0.01		10	0	1	.268	1.44		9	5	0	.334	1.78
10	2	3	.534	0.12		10	0	0	.231	7.95		9	4	3	.408	0.02
10	2	2	.456	0.99		9	8	0	.499	0.03		9	4	2	.365	0.22
10	2	1	.388	5.30		9	7	1	.488	0.02		9	4	1	.324	1.13
10	2	0	.329	18.14		9	7	0	.435	0.17		9	4	0	.290	3.58
10	1	3	.442	0.04		9	6	2	.474	0.06		9	3	3	.362	0.04
10	1	2	.376	0.60		9	6	1	.425	0.23		9	3	2	.324	0.26
10	1	1	.317	3.71		9	6	0	.381	0.56		9	3	1	.288	1.77
10	1	0	.275	15.14		9	5	2	.416	0.10		9	3	0	.255	7.23
9	2	3	.316	0.03		8	6	0	.270	0.11		8	2	2	.210	0.14
9	2	2	.284	0.26		8	5	1	.267	0.11		8	2	1	.188	1.24
9	2	1	.253	2.19		8	5	0	.242	0.46		8	2	0	.169	
9	2	0	.223	9.53		8	4	2	.266	0.04		8	1	2	.187	1.46
9	1	2	.249	0.19		8	4	1	.240	0.33		8	1	1	.166	
9	1	1	.221	1.84		8	4	0	.217	1.47		8	1	0	.147	9.31
9	1	0	.193	9.03		8	3	2	.239	0.08		8	0	2	.166	0.06
9	0	2	.217	0.07		8	3	1	.214	0.77		8	0	1	.146	0.88
9	0	1	.191	0.79		8	3	0	.193			8	0	0	.128	6.41
9	0	0	.164	5.02		8	2	3	.233	0.01		7	6	0	.212	0.02
7	5	1	.200	0.08		7	2	0	.133	5.49		6	4	0	.139	0.32
7	5	0	.191	0.16		7	1	2	.149	0.08		6	3	2	.153	0.01
7	4	2	.208	0.01		7	1	1	.132	1.10		6	3	1	.138	0.20
7	4	1	.188	0.12		7	1	0	.116	8.98		6	3	0	.123	1.35
7	4	0	.171	0.68		7	0	2	.132	0.04		6	2	2	.137	0.03
7	3	2	.188	0.03		7	0	1	.116	0.80		6	2	1	.122	0.45
7	3	1	.169	0.35		7	0	0	.101	7.92		6	2	0	.107	4.12
7	3	0	.152	2.44		6	5	0	.155	0.08		6	1	2	.121	0.06
7	2	2	.167	0.01		6	4	2	.170	0.00		6	1	1	.106	0.87
7	2	1	.150	0.78		6	4	1	.155	0.04		6	1	0	.092	8.73
6	0	2	.106	0.04		5	2	0	.086	3.36		4	3	0	.080	
6	0	1	.092	0.83		5	1	2	.099	0.03		4	3	1	.080	
6	0	0	.078	9.77		5	1	1	.086	0.58		4	2	0	.068	2.16
5	0		.128	0.04		5	1	0	.073	8.28		4	1	2	.080	0.01
4	0	1		0.02		5	0	2	.085	0.01		4	1	1	.068	0.50
4	0			0.14		5	0	1	.072	0.79		4	1	0	.056	7.21
3	1	0	.100	0.79		5	0	0	.060	12.10		4	0	2	.067	0.02
5	2	2	.113	0.01		4	5	0	.106	0.02		4	0	1	.056	
5	2	1	.099	0.28		4	4	0	.093	0.06		4	0	0	.045	14.6
						4	3	2	.092	0.03		4			.075	0.01
3	3	2	.086	0.00		3	0	0	.032	18.64		1	2	1	038	0.02
3	3	1	.075	0.02		2	0	0	.062	0.02		1	2	0	029	0.58
3	3	0	.064	0.25		2	0	0	.051	0.11		1	1	1	028	0.12
3	2		.064	0.08		2	0	0	.041	3.95		1	1	0	019	4.76
3	2	0	.053	1.53		2	0	0	.040	0.02		1	0	1	019	0.34
3	1	2	.064	0.01								1	0	0	110	34.58
3	1	1	.053	0.31			0	2	.040	0.01		0	1	1	018	0.21
3	1	0	.043	7.00					.030	0.41		0	1	0	018	0.04
3	0	3	.052	0.02					.020	24.13		0	0	1	009	3.05
3	0	1	.042	0.51		1	3	0	.038	0.04		0	0	1	009	0.26

X = most probable number of bacteria per ml. in the center dilution.
P = probability of occurrence of such a combination of tubes.

* Halvorson, H. O., and Ziegler, N. R., Jour. Bact. XXV, No. 2, Feb. 1933, P. 121.

39

Handwritten labels: ANOSTM · BASKET BALL · SNOW (?) · 5ʰᵗ Position EN HAUT · BIG FURRY BAG + PROJECTION SCREEN · Pumpkin · Necklace · MEDIUM BAG · BAG (SMALL) · BELL · PARASOL · RED BALL · RED BALL · CIRCLE DANCE · PARASOL

Shapes hold meaning. A square looks in: a rectangle looks out. The short ends of the rectangle feel like a gesture toward infinity. Here, a consideration of all objects and bodies rectangular in my work—resisting the distinction.

Gelatin		
Glucose broth	Bed, Glasses	
Maltose broth	Dancer, Scarf	
Mannitol broth	Mallet, Ballerina leg	
Sucrose broth	Ruler, Flower	
Lactose broth	Bench, Logs	

	S. cerevisiae	T. kefir
Agar	Stick, Cane	
Potato	Braid, Little cane	
Broth	Mic stand, Umbrella	
Peptone	Crutch, chain of coins	
Gelatin	Cigarette, Cigar	
Milk	Recorder, Guitar	
Glucose broth	Knife, Fork	
Maltose broth	Lamp, Sticks	
Mannitol broth	Rifle, Knitting needles	
Sucrose broth	I.V. Pole, Stickpath	
Lactose broth	Pencil, Bush	

42

Arc

The most lyric of shapes. As opposed to a circle, an arc starts and finishes, moves from point A to point B, but the curve implies humanity: change, nuance, doubt.

SEOKYO HOTEL

#354-5 SEOKYO-DONG, MAPO-KU,
SEOUL, KOREA. TELEX : K26780
TEL. 324-0181~7, 323-8861~7

Drawing the Surface of Dance Structures and Scores

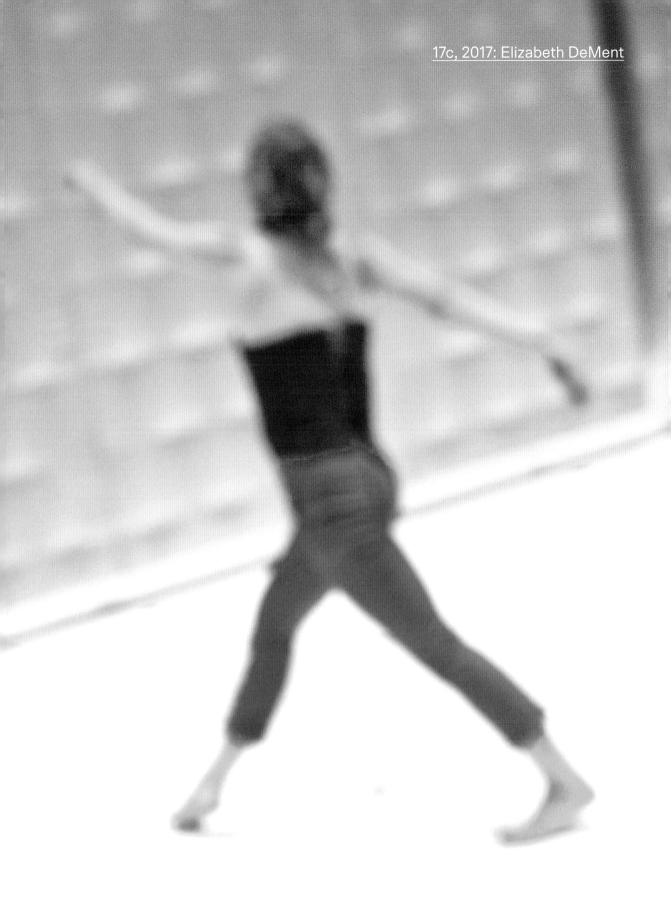

Trio

A score for three, suggesting the metaphor of a necklace and the development of its components and circle shape for a trio.

Date received ___ TRIO ___

Gram stain ___ Shape of individual cells ___ Motility ___ Spores ___

Agar slant
 (Gross morphology)

Starch

Sucrose
 Indol

Gelatin

Milk

Potato

Nitrate agar

Glucose broth

Maltose broth

Mannitol broth

Sucrose broth

Lactose broth

 Diagnosis

Stage Directions Plus Birds

Pillaging plays for their movement, while rejecting the hierarchy of theatrical dialogue and narrative as the most valuable parts of the play, this score emphasizes notions of both the pedestrian and detritus. In a sense the score asks what is danceable and what goes unseen in a text. Here, the stage directions generate action through randomly selected directives from playwrights, mixed in with a chart of stately birds who all face stage right. In my 20s, I worked as a choreographer and sound designer in a theater company that staged the work of playwrights. Upon reading the plays, I was immediately drawn to the stage directions, for their generative choreographic nature—both sublime and absurd when isolated from the text.

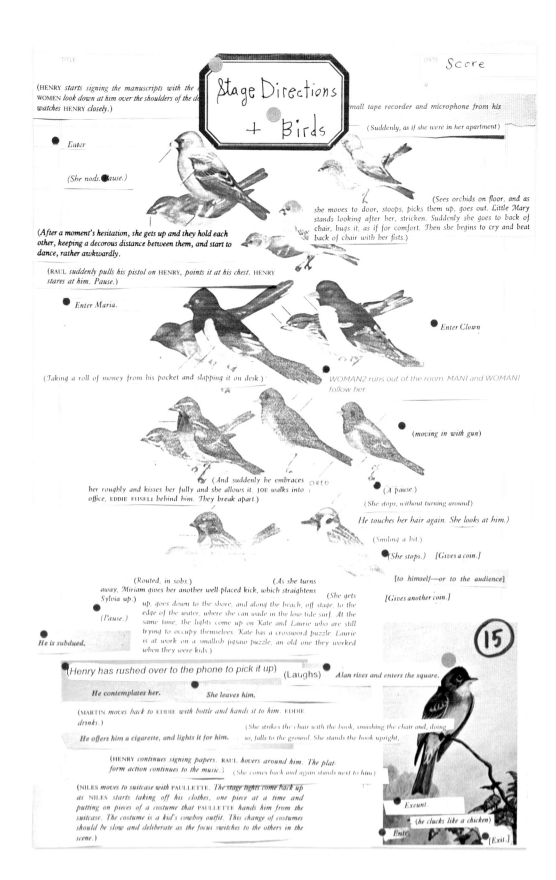

(HENRY *starts signing the manuscripts with the* ... WOMEN *look down at him over the shoulders of the d*... *watches* HENRY *closely.*)

Stage Directions + Birds

...*mall tape recorder and microphone from his*...

(*Suddenly, as if she were in her apartment*)

Enter

(*She nods. Pause.*)

(*Sees orchids on floor, and as she moves to door, stoops, picks them up, goes out. Little Mary stands looking after her, stricken. Suddenly she goes to back of chair, hugs it, as if for comfort. Then she begins to cry and beat back of chair with her fists.*)

(*After a moment's hesitation, she gets up and they hold each other, keeping a decorous distance between them, and start to dance, rather awkwardly.*)

(RAUL *suddenly pulls his pistol on* HENRY, *points it at his chest.* HENRY *stares at him. Pause.*)

Enter Maria.

Enter Clown

(*Taking a roll of money from his pocket and slapping it on desk.*)

WOMAN2 *runs out of the room.* MAN1 *and* WOMAN1 *follow her.*

(*moving in with gun*)

(*And suddenly he embraces her roughly and kisses her fully and she allows it.* JOE *walks into office,* EDDIE FUSELI *behind him. They break apart.*)

ORED

(*A pause.*)

(*She stops, without turning around*)

He touches her hair again. She looks at him.)

(*Smiling a bit.*)

(*She stops.*) [*Gives a coin.*]

(*Routed, in sobs.*)

(*As she turns away, Miriam gives her another well-placed kick, which straightens Sylvia up.*)

(*She gets up, goes down to the shore, and along the beach, off stage, to the edge of the water, where she can wade in the low tide surf. At the same time, the lights come up on Kate and Laurie who are still trying to occupy themselves. Kate has a crossword puzzle. Laurie is at work on a smallish jigsaw puzzle, an old one they worked when they were kids.*)

(*Pause.*)

[*to himself—or to the audience*]

[*Gives another coin.*]

He is subdued.

(15)

(Henry has rushed over to the phone to pick it up) (Laughs) Alan rises and enters the square.

He contemplates her. She leaves him.

(MARTIN *moves back to* EDDIE *with bottle and hands it to him.* EDDIE *drinks.*)

(*She strikes the chair with the book, smashing the chair and, doing*

He offers him a cigarette, and lights it for him. *so, falls to the ground. She stands the book upright,*

(HENRY *continues signing papers.* RAUL *hovers around him. The plat-form action continues to the music.*) (*She comes back and again stands next to him*)

(NILES *moves to suitcase with* PAULLETTE. *The stage lights come back up as* NILES *starts taking off his clothes, one piece at a time and putting on pieces of a costume that* PAULLETTE *hands him from the suitcase. The costume is a kid's cowboy outfit. This change of costumes should be slow and deliberate as the focus switches to the others in the scene.*)

Exeunt.

(*he clucks like a chicken*)

Ente

[*Exit.*]

Layering: two or more systems simultaneously occurring, informing, and bouncing off of each other. Put two things together without your interference and trust the gods to create connections where you couldn't know they exist. The phenomena of the world are variously interconnected—a vast circle, but we are unable to see the two ends coming together because we can't see that far. But we can allow things to connect if we let them be. And when they don't relate, that has meaning in itself. The layering of ideas is an effort to sync up with the compositional and thematic synchronicities in the universe.

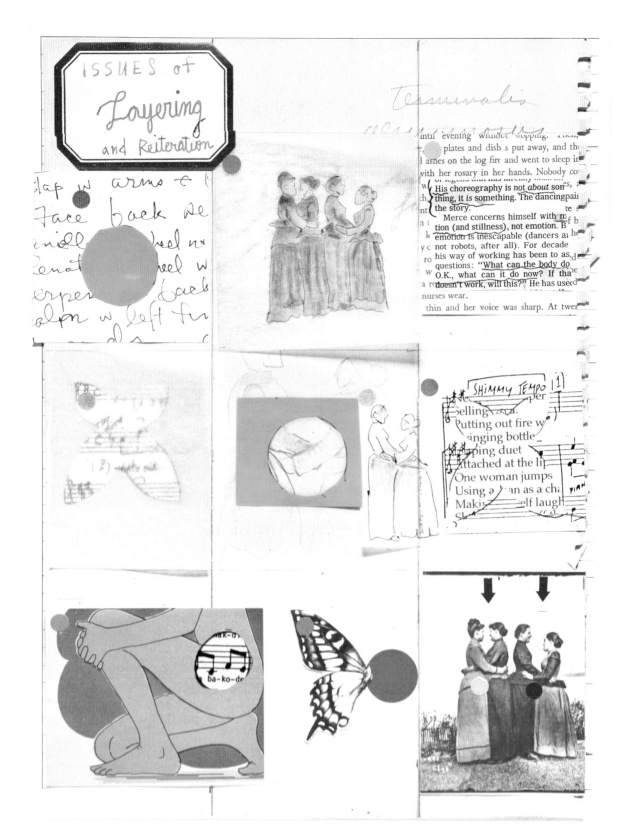

ISSUES of *Layering* and Reiteration

until evening without stopping. Then,
plates and dishes put away, and the
ashes on the log fire and went to sleep in
with her rosary in her hands. Nobody co

His choreography is not *about* some,
thing, it *is* something. The dancing pain
the story.

Merce concerns himself with m
tion (and stillness), not emotion. B
emotion is inescapable (dancers a he
not robots, after all). For decade
his way of working has been to as
questions: "What can the body do
O.K., what can it do now? If tha
doesn't work, will this?" He has used
nurses wear.

thin and her voice was sharp. At twer

SHIMMY TEMPO
elling
utting out fire w
inging bottle
ping duet
ttached at the li
One woman jumps
Using a an as a cha
Maki elf laugh

This trio score serves to generate the structure of a solo plus duet. Here I was working with symmetry: two dancers in gold body suits as the butterfly wings, and a pop singer in the middle. Our bodies display many symmetries, but so does our behavior—mutuality and justice and agreement—we display an urge for symmetry in our lives as well.

Butterfly wings

LIZZIE ANNIE ADELE

ATTENDANCE

Butterfly as a choreographic structure

Drawing the Surface of Dance Structures and Scores

I once overheard a docent in a museum suggest that there are three fundamental objects in painting: the mask, the scroll, the urn. I loved this idea— that narrative painting could be pared down to three essential shapes.

Mask: The generative, interpretive acting out of all things.
Scroll: The recording of all things.
Urn: The holding of all things.

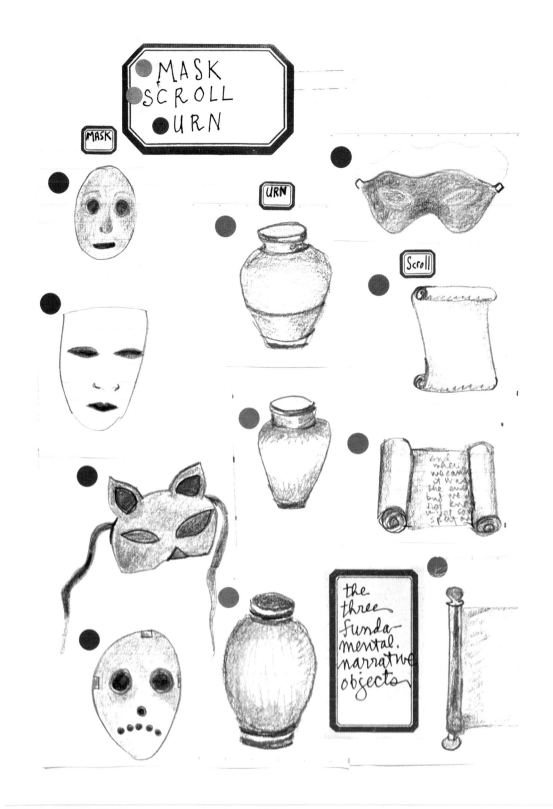

MASK
SCROLL
URN

MASK

URN

Scroll

the three funda- mental. narrative objects

Robert Rauschenberg famously erased a de Kooning, leaving the erasure marks and the lightest remains of the refined, sacrificial drawing. Here the idea is two-fold: we erase the master in order to find space for ourselves to emerge in their intense shadow, but we leave remnants of their effect on our work.
I first employed ideas around erasure in music.
I choreographed a Stravinsky nocturne as directly as I could, attending to tone, accent, rhythm and instrumentation. Then I kept the choreography but erased the actual music; the audience never heard the Stravinsky piece but instead they saw the erasure marks. After that I continued to erase objects, text, and movement.

Issues of

ERASURE

Robert Rauschenberg famously erased a DeKooning, leaving the lightest remains of the refined, sacrificial drawing. Here the idea is two-fold: we erase the master in order to find space for ourselves to emerge in their beautiful shadow, but we leave remnants of their affect on our work.

I sometimes choreograph using verbs as prompts for their innate property of activation. This was a score for a duet made for Tymberly Canale and Mikhail Baryshnikov in a piece based on a Chekhov short story. The duet expresses a brief, aspirational love affair that is ruining the woman's family. I used these particular verbs to generate a state of regret, impossibility and desire.

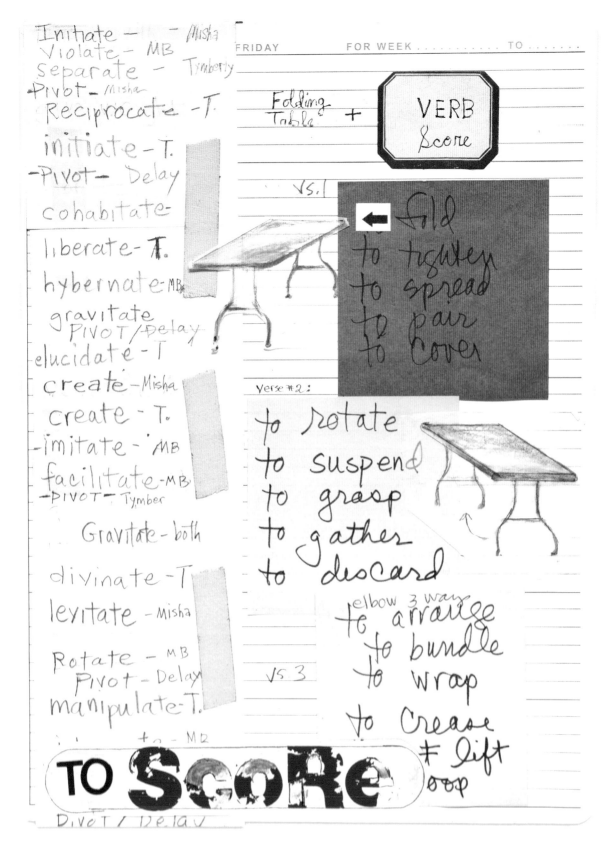

Initiate — — Misha
Violate — MB
separate — Tymberly
-Pivot- Misha
Reciprocate - T.
initiate - T.
-Pivot- Delay
cohabitate-

liberate - T.
hybernate - MB
gravitate
 PIVOT/Delay
elucidate - T
create - Misha
create - T.
-imitate - MB
facilitate - MB
-PIVOT- Tymber

Gravitate - both

divinate - T
levitate - Misha

Rotate — MB
 Pivot - Delay
manipulate - T.

· · · · to - MB

Divot / Delay

Folding Table + **VERB Score**

Vs. 1

← fold
to tighten
to spread
to pair
to cover

Verse #2:

to rotate
to suspend
to grasp
to gather
to discard

elbow 3 ways
to arrange
to bundle
to wrap
to crease
lift
oop

Vs. 3

TO SCORE

Verbs Plus Rolling Chair

A score commissioned by La MaMa just days after Trump became President, as an antidote to the fear and confusion setting in at that moment. I employed a dance score of verbs, verbs that were in the air in that moment—plus the rolling chair I was sitting in, for its kineticism. This score was shared internationally with dance-makers to freely choreograph a dance from. It served as a protest song in the form of a dance score.

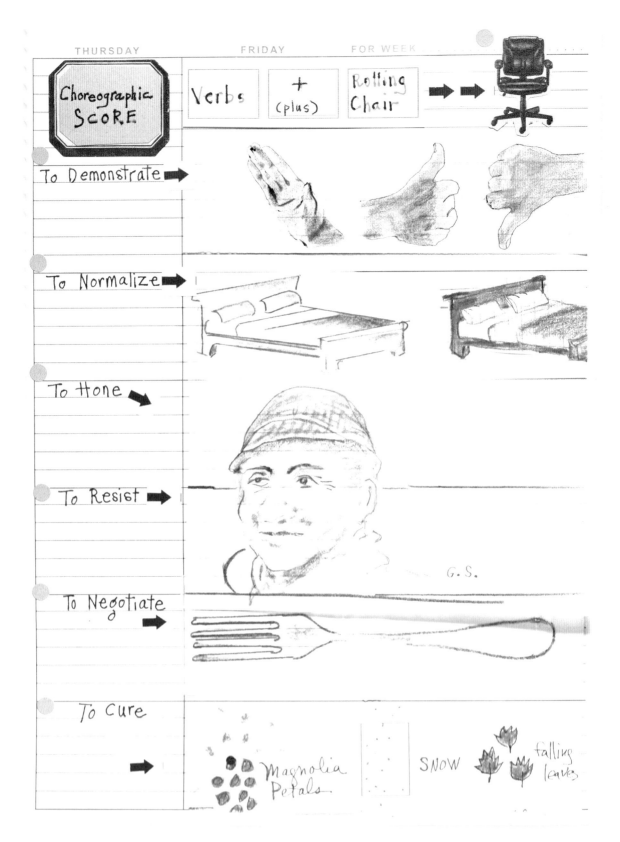

Choreographic SCORE

Verbs + (plus) Rolling Chair

To Demonstrate

To Normalize

To Hone

To Resist

G.S.

To Negotiate

To Cure

Magnolia Petals

SNOW

falling leaves

Prepositions

Further investigation into using grammatical forms to generate movement: prepositions are a powerful language tool to connect, tangle, and disrupt bodies in space.

PREPOSITIONS

For dance-making

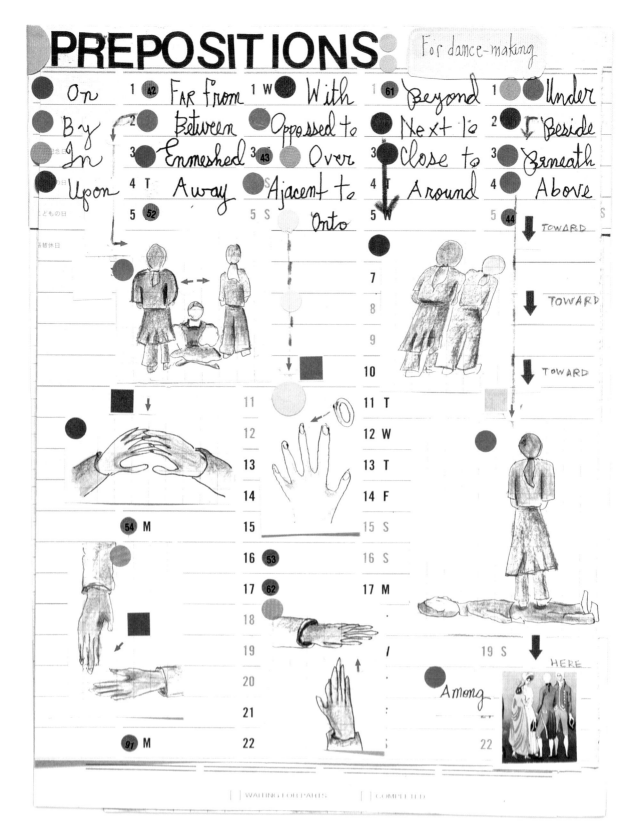

On
By
In
Upon

1 42 Far from
2 Between
3 Enmeshed
4 T Away
5 52

1 W With
Opposed to
3 Over
Adjacent to
5 S Onto

1 61 Beyond
2 Next to
3 Close to
4 Around
5 W

1 Under
2 Beside
3 Beneath
4 Above
5 44 TOWARD

7
8
9
10

7 TOWARD

11
12
13
14
15

11 T
12 W
13 T
14 F
15 S

TOWARD

54 M

16 53
17 62
18
19
20
21
22

16 S
17 M

91 M

15
16
17
18
19
20
21
22

19 S HERE

Among

22

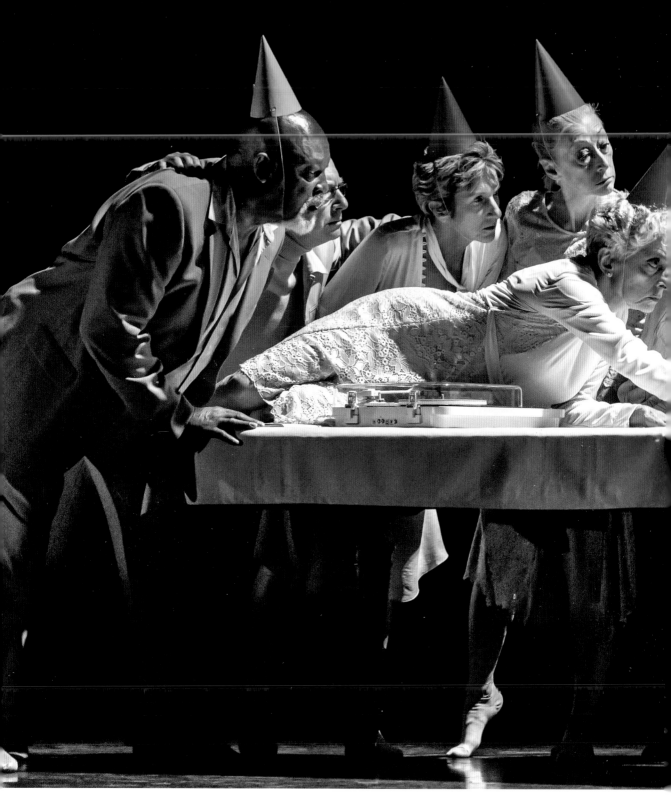

The Road Awaits Us, 2017: Elixir Dance Co., Sadler's Wells and Paul Lazar

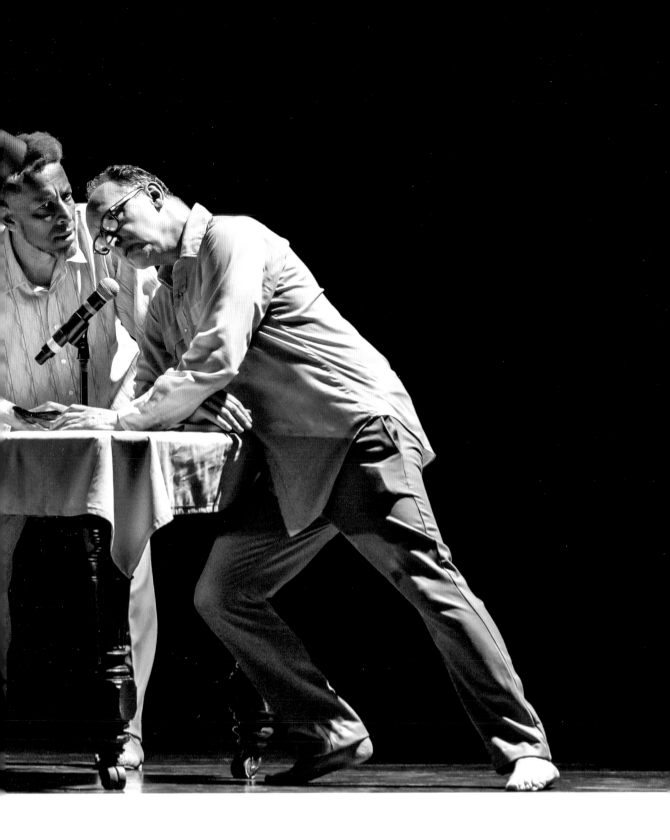

This score's directives address pauses in the act of speaking, and here the score assigns specific beats of silence for specific punctuation marks. I made this score to build a structural underpinning to a diary entry from 1660, giving the performer an underlying silence structure for speaking. Where there is no silence/punctuation, the performer was directed to speak quickly with no pauses.

Punctuation Score
—
Text + Time

TEXT ➡

• Blessed be God, 2

At the end of the last
year I was in very good health, 2

... 6

I lived in Axe Yard having my wife

1 [Bess] 1
6 ... And
~~Hamag~~ no more in family than us two. 4
6 ↰ My wife ... gave me
hopes that ~~she the~~ was with child,
but on the last ~~day on the last~~
day of the year ... the hope belied. 4
↑
6

My own, private condition ...
esteemed rich, but indeed very poor. 4

This morning I rose,
... put on my suit with great skirts...
[...]
I staid at home all the afternoon
, looking over my accounts. 4

And so here begun this _5_ diary.

TIME ⬇

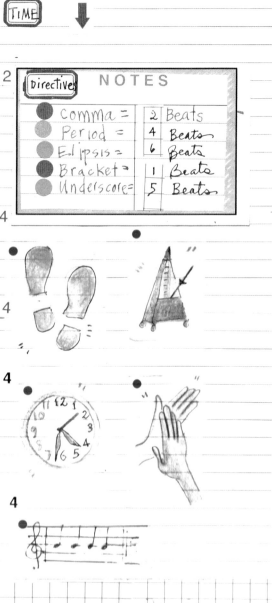

Directives	NOTES		
⬤	Comma =	2	Beats
⬤	Period =	4	Beats
⬤	Ellipsis =	6	Beats
⬤	Bracket =	1	Beats
⬤	Underscore=	5	Beats

The chair is the pelvis of the inanimate world.
Here it serves as a way to show directionality
or facings on stage.

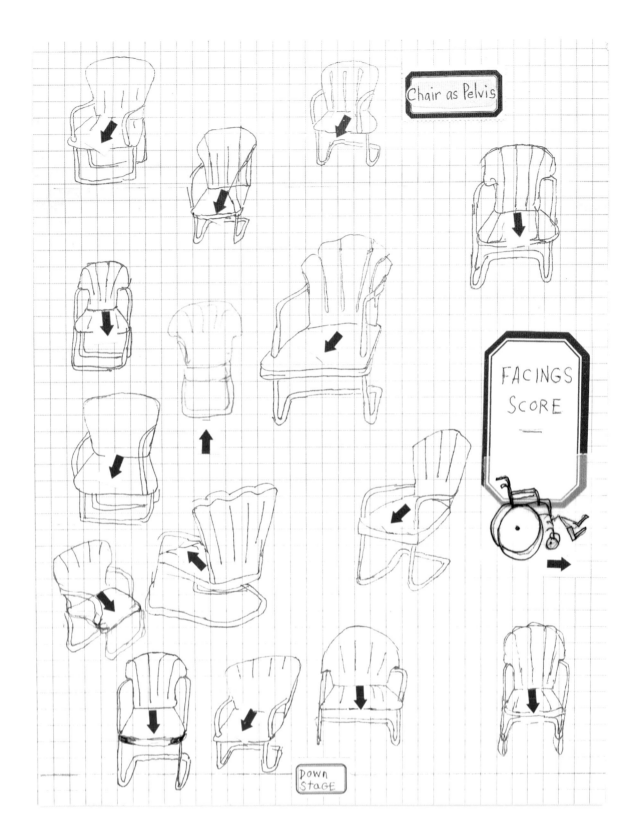

Chair as Pelvis

FACINGS SCORE

DOWN STAGE

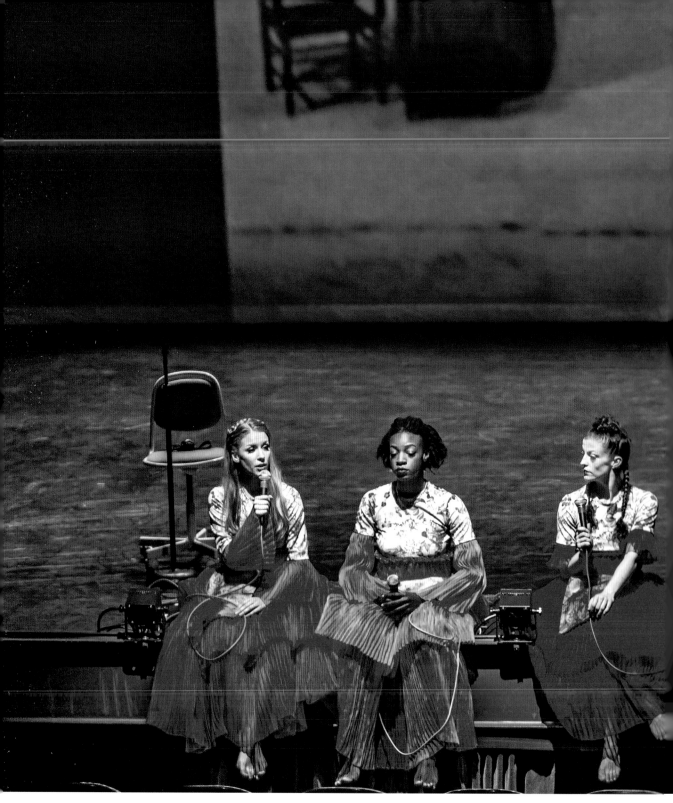

<u>i used to love you, 2017/2019</u>: Martha Graham Dance Co.

Drawing the Surface of Dance Structures and Scores

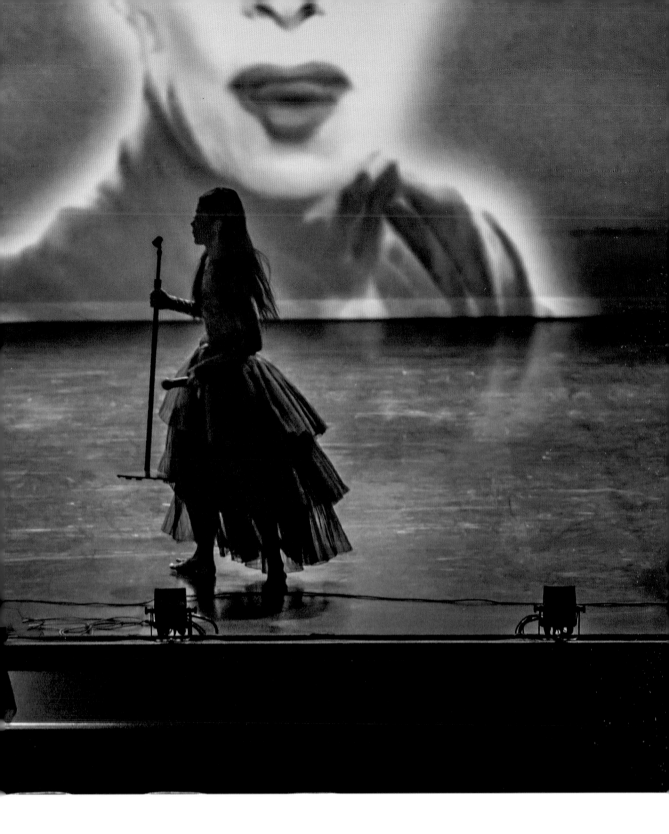

Staging Score/A Forest of Mics

This is a score I drew for a rock-singer; the score delays her use of the ubiquitous downstage center position. Here I place microphones in positions all around the stage facing all directions; each placement has its own tonality, all giving only partial access to the face and figure. During the first half of the concert, she makes her way through these various locations, ending the last song downstage center, having duly earned this familiar position. That the audience regards the performer from so many angles and proximities before they are granted full exposure gives them a sense of closure when she arrives "home."

Chance Radio Score

This is a simple list of radio stations used in conjunction with rolling dice to create a sound score for a piece by Paul Lazar called *Cage Shuffle*. We tried it in rehearsal; Paul rejected it, choosing instead to dance in silence.

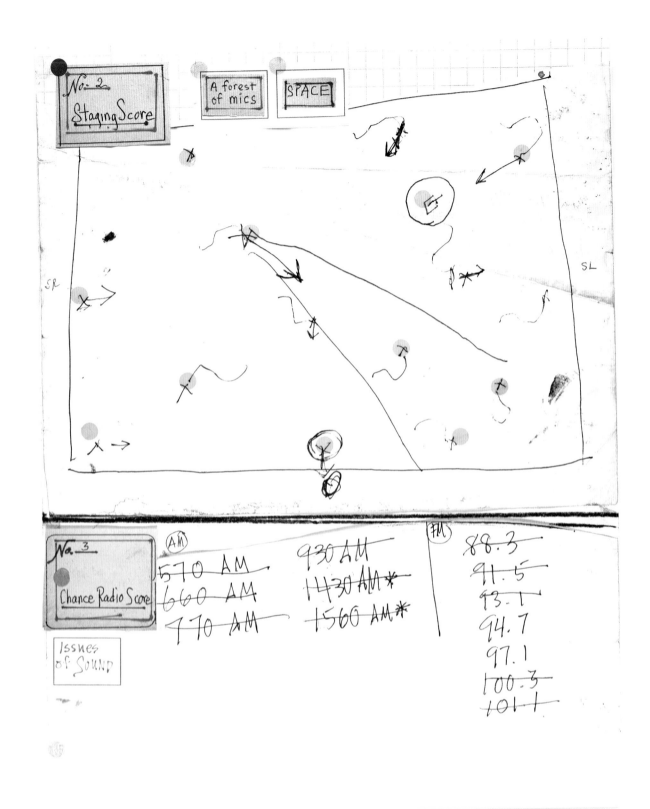

No. 2
Staging Score

A forest of mics

SPACE

SR

SL

No. 3
Chance Radio Score

Issues of SOUND

AM

570 AM
660 AM
770 AM

930 AM
1430 AM *
1560 AM *

FM

88.3
91.5
93.1
94.7
97.1
100.3
101.1

Words for Dance-Making

In a culture that has an impoverished use of language around movement, here I create a chart of words, intended to be both generative and diagnostic.
My teacher, Robert Ellis Dunn, encouraged us to use non-technical, contrasting word pairs to talk about movement. He would say: this dance is smooth, not spikey, or, this phrase is loose not tight.

WORDS for DANCE-MAKING

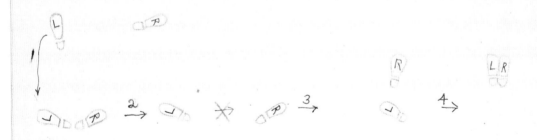

●Point A	Fragmentation	Prosaic	Horizontality	●Point B
(Dis)continuity	Surface	Retrograde	Palimpsest	Relocation
Time	Pattern	Musicality	Error	Verbs
(Lack of) Mask	Erasure	Tempo	Emotionality	Prepositions
Causation	Synthesis	Muscularity	Line	Nouns
Variation	Dynamics	Energy	Scale	Imagery
Rhythm	Form	Shape	Duration	Relationship
Site	Timing	Position	Space	Systems
History	Literature	Objects	Symmetry	Corners
Dryness	Connection vs disconnection		A-Symbolic	Virtuosities
Detachment	Twinning	Layer	Found	Red Herrings
Repition	Reiteration	Disjunction	Dance Objects	Poetics
Reitition	Frame	Poetic Forms	Mother Nature	Motif
Repetition	Facing (Pelvis)	Folk Forms	Stuff	Un-Pretend
inOrganic	minimize	Intentionality	Chance	Economy

$\dfrac{3}{}$

Big Dance Theater
In Photos

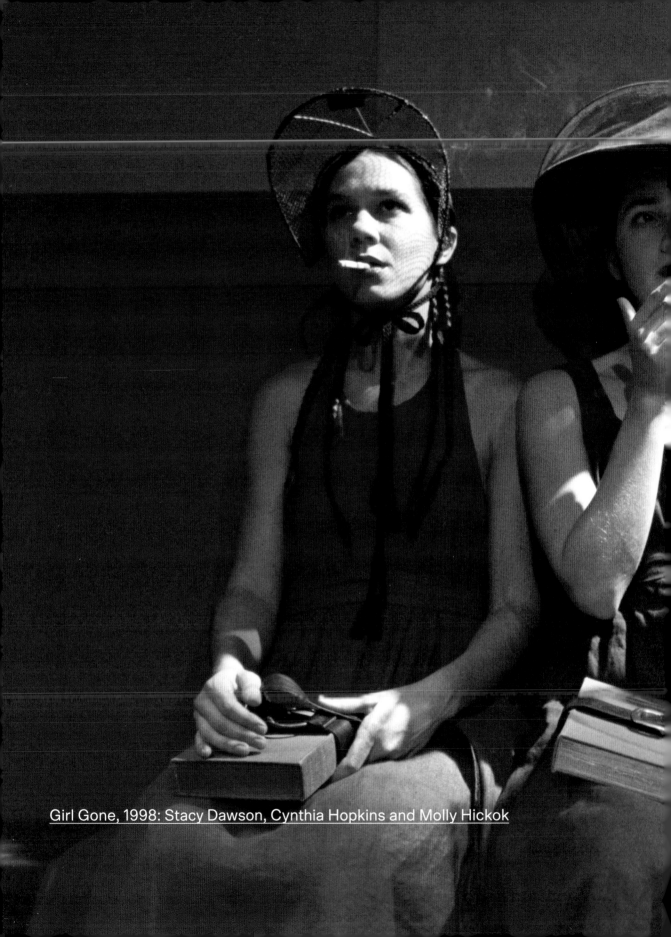

Girl Gone, 1998: Stacy Dawson, Cynthia Hopkins and Molly Hickok

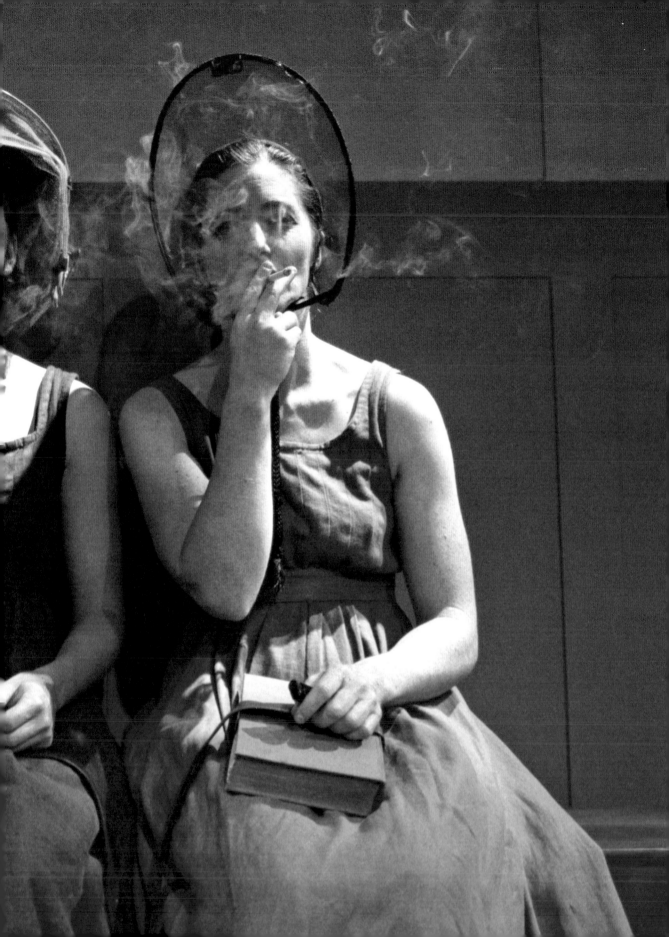

Alan Smithee Directed This Play, 2014:
Kourtney Rutherford and Aaron Mattocks

Drawing the Surface of Dance Big Dance Theater

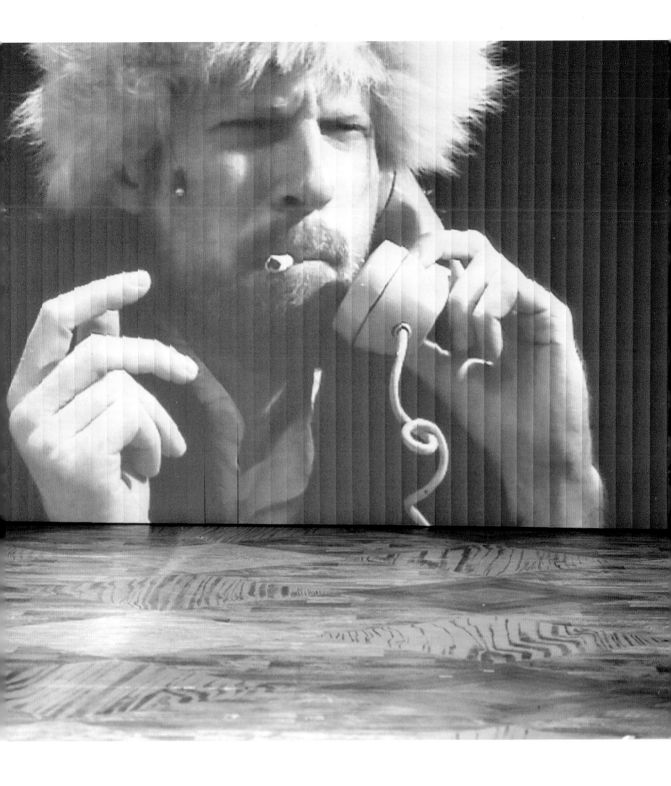

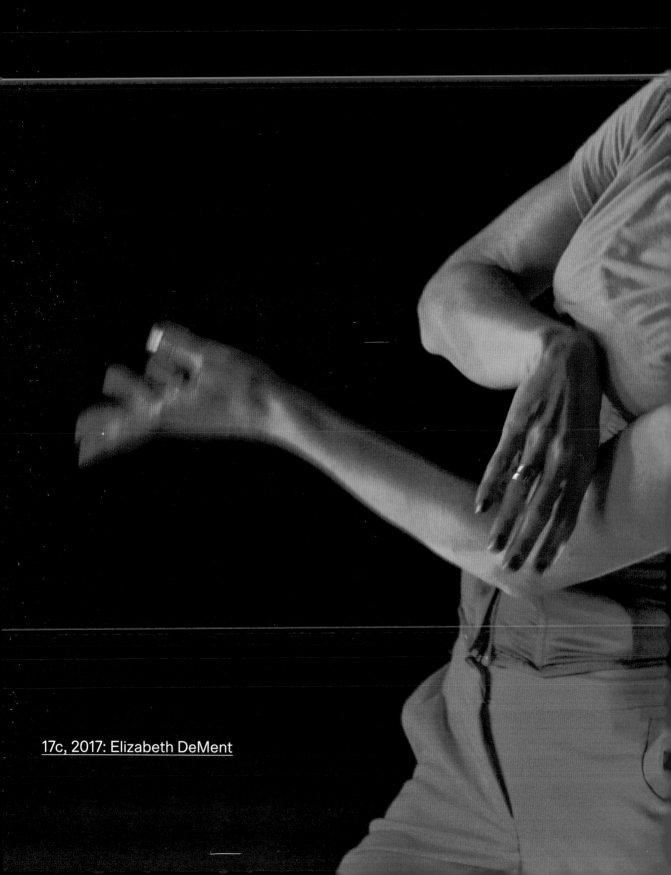

17c, 2017: Elizabeth DeMent

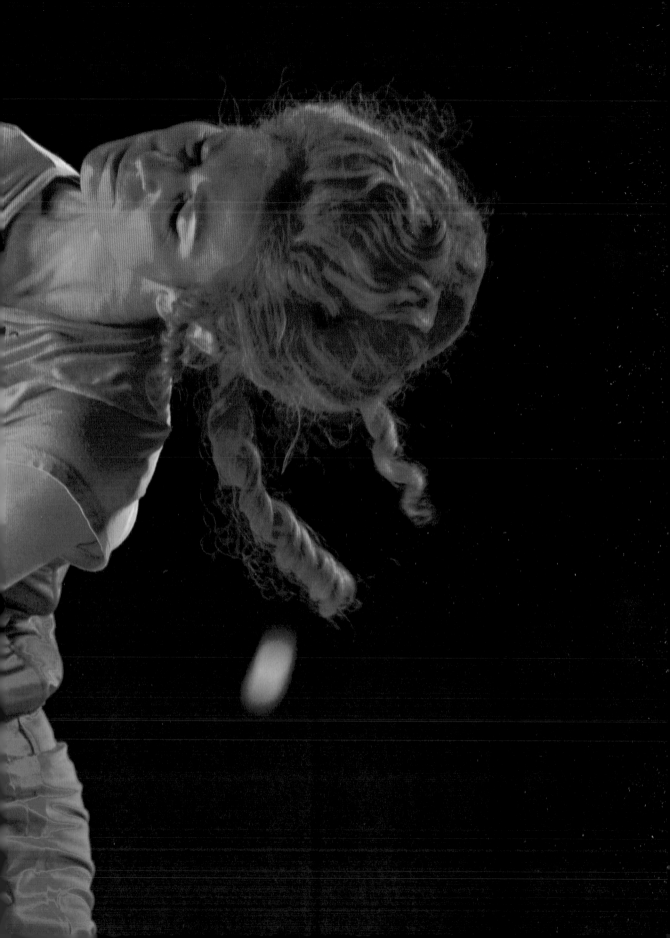

Bavarian Peasant Girl, Franz Seraph von Lenbach, 1860 (Research/Process)

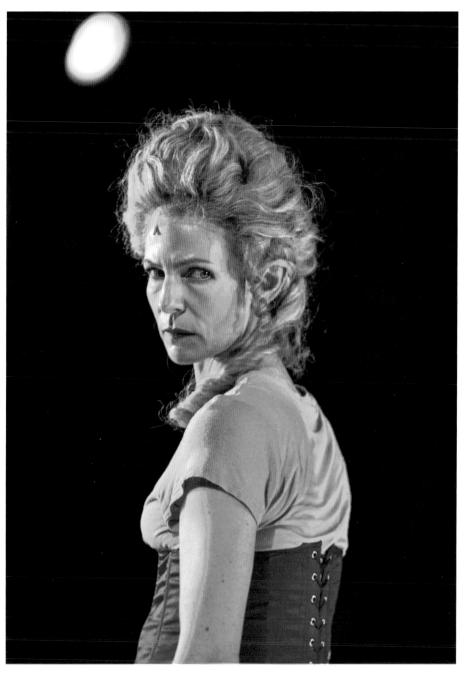

17c, 2017: Elizabeth DeMent

Ballet, 2018: Elizabeth DeMent and Omagbitse Omagbemi

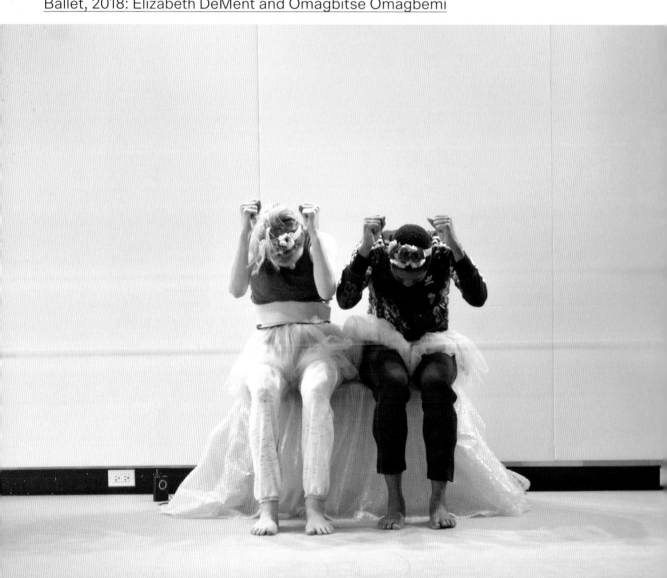

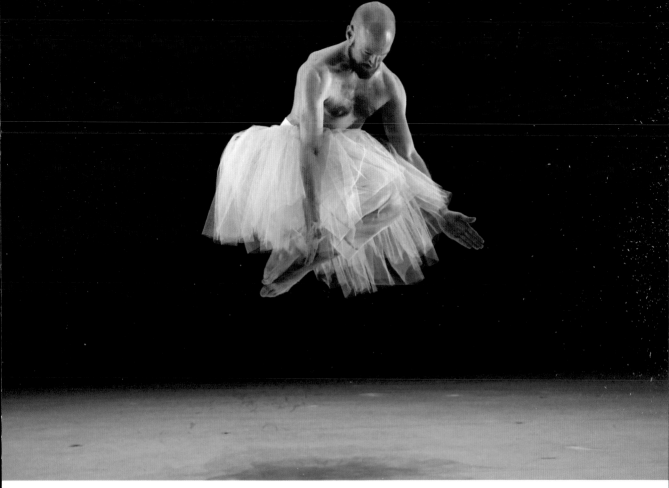

Short Ride Out, 2016: Aaron Mattocks

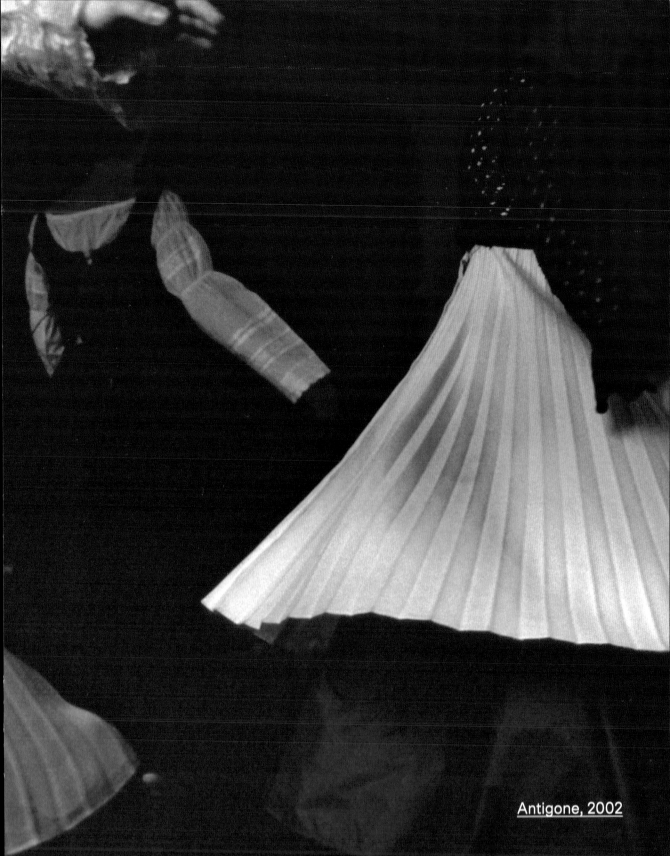

Antigone, 2002

City of Brides, 1995: Tymberly Canale and Stacy Dawson

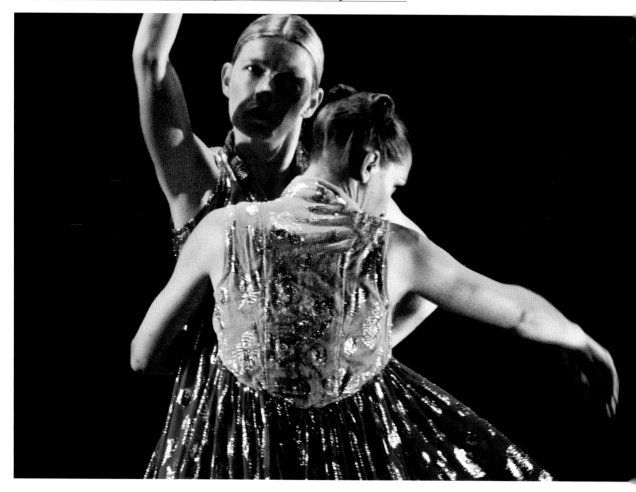

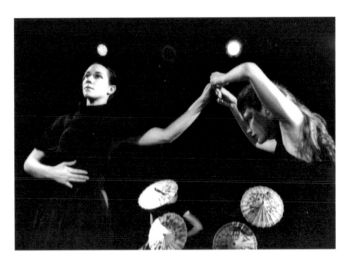

Another Telepathic Thing, 2000:
Stacy Dawson and Tymberly Canale

The Art of Dancing, 2015: Aaron Mattocks

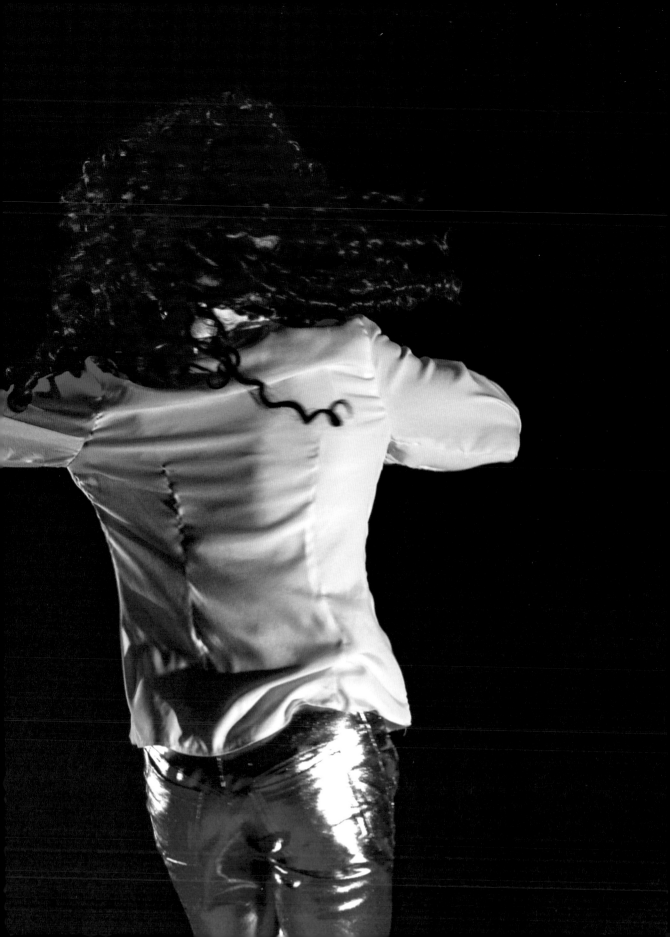

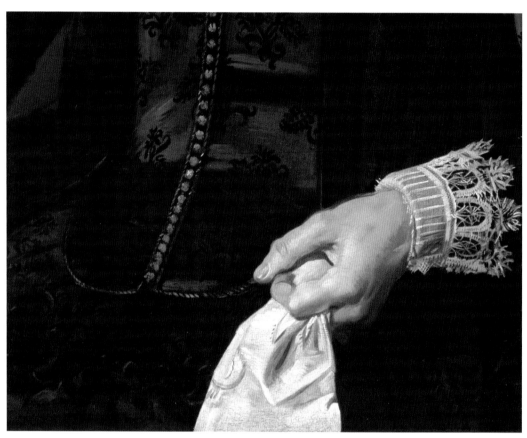

Portrait of a Lady, Frans Hals, 1627, The Art Institute of Chicago
(Research/Process)

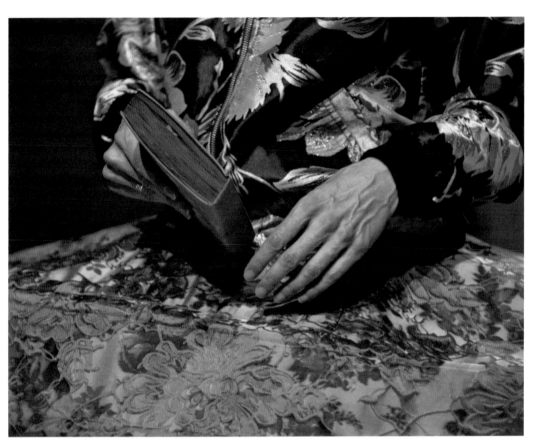

17c, 2017: Elizabeth DeMent

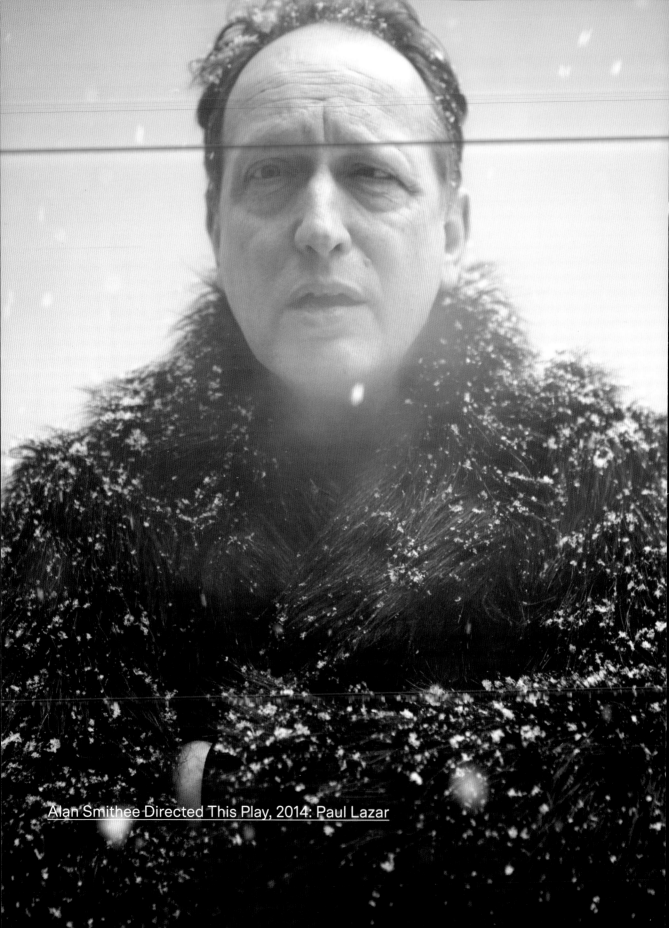

Alan Smithee Directed This Play, 2014: Paul Lazar

Tetrameter – 4 beats per
measure

A job's been 4 beats
Offered to me! 4
Where? Nebraska! 4
Where? Nebraska! 4

Why did you not
Say this to me?

Sometime was needed
For to think
Before I spoke
To you my wife.

It's <u>beat</u> um <u>beat</u> (4)
Head of the ~~department~~ 3
DEPARTMENT! 3

I really don't
Want to leave here
I love the schools –
~~The~~ pediatrician!

Head of the
Department! x2

Tetrameter based on a scene from Terms of Endearment
(Research/Process)

Drawing the Surface of Dance Big Dance Theater

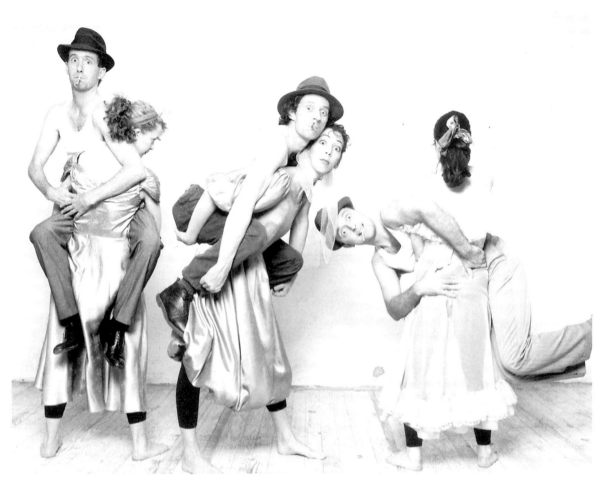

The Gag, 1993: Josh Broder, Renata Hinrichs, Lenard Petit, Jennifer Sewall, Umit Celebi, and Molly Hickok

Antigonick, 2016: Chris Giarmo
and Yvonne Rainer

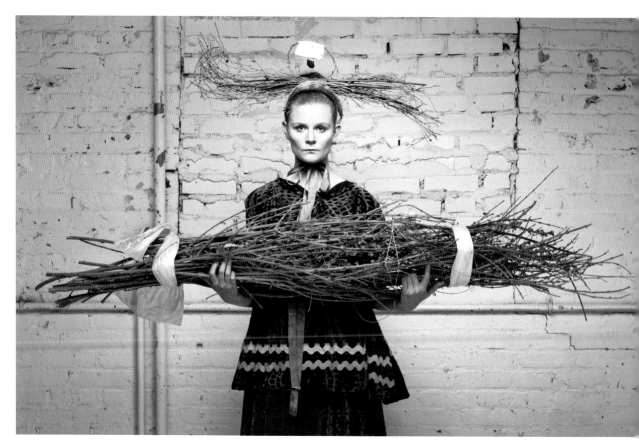

Ich, Kürbisgeist, 2012: Kourtney Rutherford

Drawing the Surface of Dance Big Dance Theater

Kourtney
dress

Tymberly
dress

Costuming for Comme Toujours Here I Stand
(Research/Process)

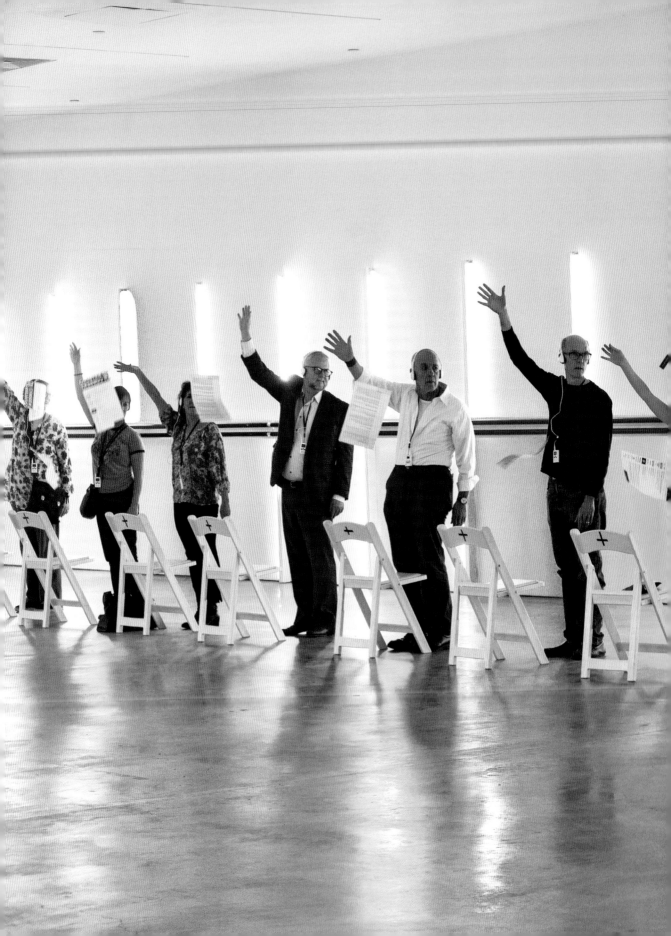

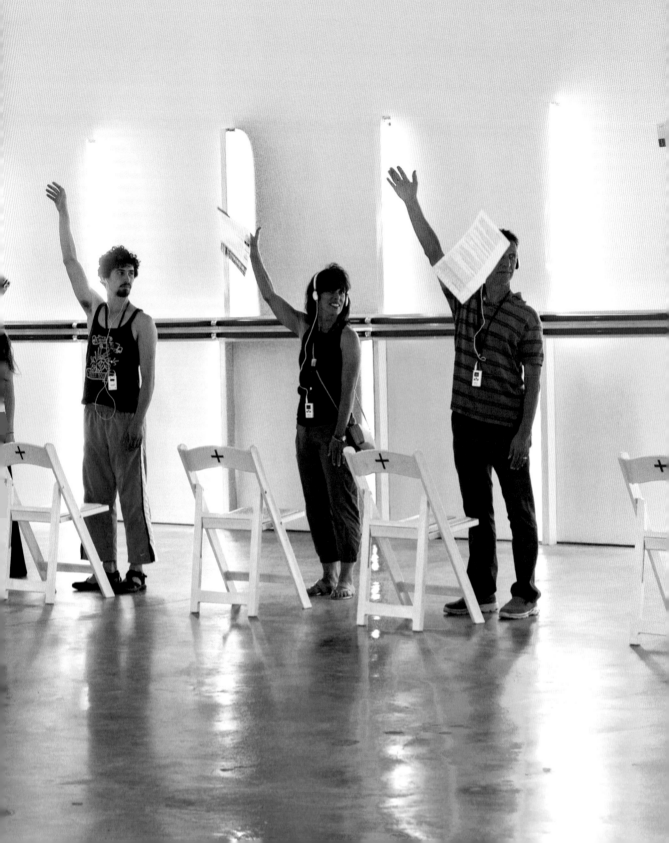

American Utopia, 2018: David Byrne and band

Drawing the Surface of Dance Big Dance Theater

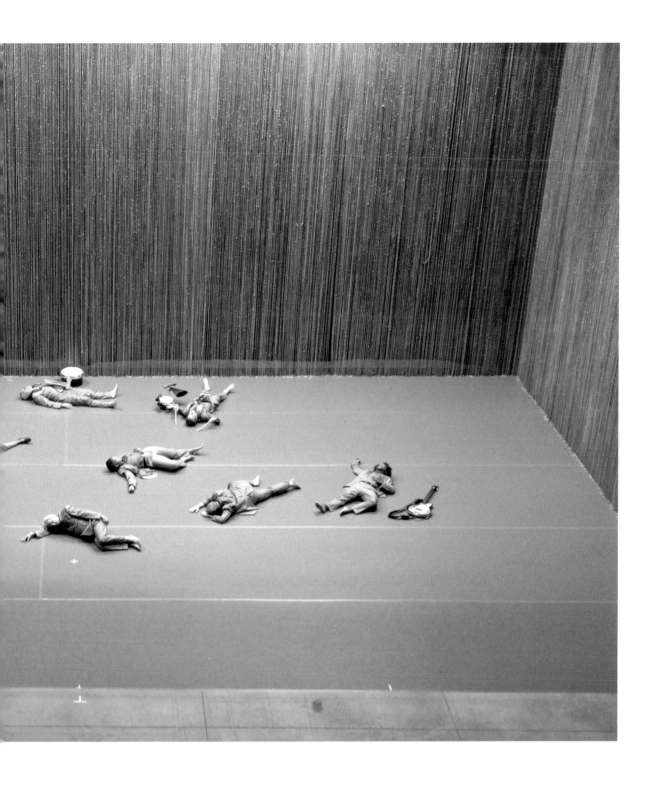

London Cemetery (Research/Process)

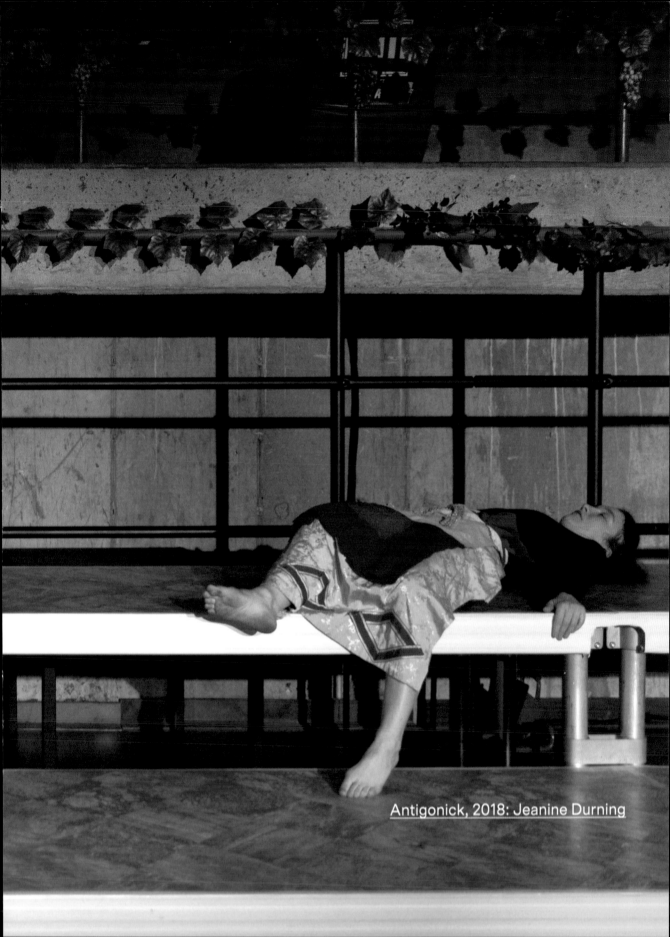

Antigonick, 2018: Jeanine Durning

4

Elements of Composition
A Deck of Cards

Sourcing the grid and chromatic structure of Mexican Lottery Cards to break down elements of choreographic composition. The lottery cards are rectangular in shape, each one with a single symbolic image, framed by a saturated color. Here, parsing dance-making tools and concepts into small parts, addressing the belief that images can refract and deepen text-content. And alluding to the notion that compositional tools could be played like a card game— obliquely referencing chance technique. Deal out the cards and make something from all the information on the cards the dealer gives you.

Elements of Composition

Sourcing the grid and chromatic structure of Mexican Lottery Cards to break down elements of choreographic composition. The lottery cards are created in linear rectangles, each one with a singular symbolic image, framed by a saturated color. Here, parsing dance-making tools and concepts into small parts, addressing the belief that images can refract and deepen text, and alluding to the notion that the compositional tools of dance could be played like a lottery—obliquely referencing chance technique.

7

SPACE 25

46

LIGHT 26

43

SOUND 27

14

TIME 24

35

CHANCE 29

1

OUR BODY

Scale

37

SYMBOLs

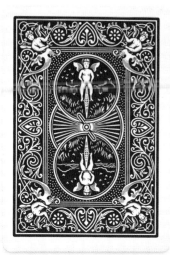
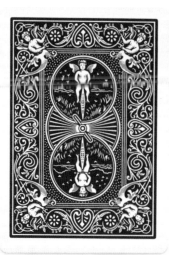
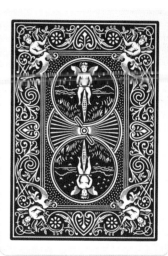

T Color

46

CONTENT

ALIGNMENTS

Cause + Effect

TONE

INFINITIF	PARTICIPE PAS
étudier	étudié
parler	
aller	
dormir	
naître	
partir	
vivre	

Grammar

SEATING

FORM

CHART

Directionality

21

GESTURE 20

21

s Repetition

M TEMPO

45

ERASURE

53

Reversal

8

FRAGMENTATION

Step selector

- Depress the suction power s
 until the required power sett
 appears in the indicator win

- Hold the wand, with the floor
 attached, off the floor. Turn o
 appliance and see whether t
 marker completely fills the in
 window. If it does.

- Change the dustbag, even if
 completely full.

Slide selector

- Move the slide selector to th
 wer sett

The Prosaic

s DUALITY

35

Symetry

ARTIFACT

NATURE

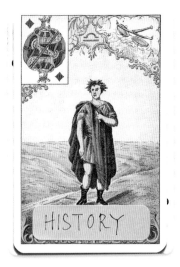

HISTORY

COSTUMES

ALGORITHM

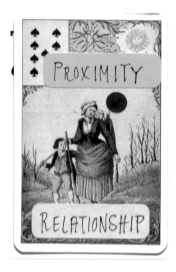

PROXIMITY

RELATIONSHIP

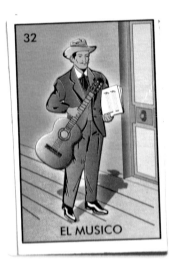

EL MUSICO

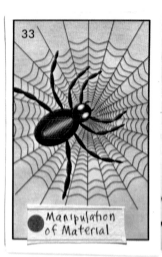

Manipulation of Material

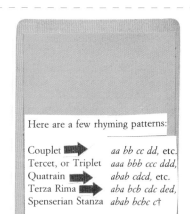

Here are a few rhyming patterns:

Couplet ➡ *aa bb cc dd*, etc.
Tercet, or Triplet *aaa bbb ccc ddd,*
Quatrain ➡ *abab cdcd*, etc.
Terza Rima ➡ *aba bcb cdc ded,*
Spenserian Stanza *abab bcbc c†*

POETICS

RITUAL

Stillness/Silence

Tempo

Development

Repurposing Materials

Folk dance/
Found dance

DETRITUS

SURFACE

36

OBJECTS 28

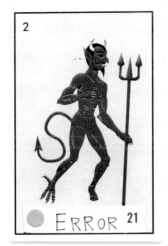

2

ERROR 21

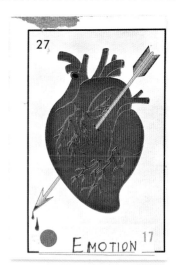

27

EMOTION 17

The bull had driven Félicité back
...ver was spurting into her face. In
...ve gored her, but she just had time
...e bars, and the great beast halted in
This adventure was talked about
...od many years, but Félicité never p...
...what she had done, as it never occu...
...ne anything heroic.
...Virginie claimed all her attention, fo...
...e little girl's nerves, and M. Poup...
...ended sea-bathing at Trouville.
In those days the resort had few visi...
...quiries, consulted Bourais, and g...
...ough for a long journey.
...Her luggage went off in Liébard's
...t. The next morning he brought a

TEXT

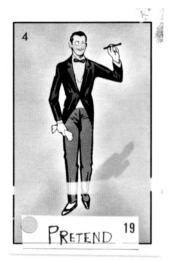

4

PRETEND 19

PATTERN 23

19

MOTION 16

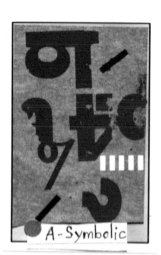

A-Symbolic

STORY

Rearrangements
On Annie-B Parson

S is for surface, the exterior of the work, what we can see, how it appears. Surface: a register of interiority, its wrapping. Surface houses and suggests the heart of the matter, without need of direct encounter. Decoration is underrated.

—Annie-B Parson, *Dance by Letter*

It's 2009, and I am at Jacob's Pillow Dance Festival, in rural Western Massachusetts, to watch Annie-B Parson teach a dance composition workshop. She has given the students, a group of about 10, an assignment involving a single, commonplace object: a microphone. As I enter the barn that houses the dance studio, they are sharing their choreographic studies. Her feedback is dry, direct; her aim here, I quickly gather, is not to make people feel good. She is trying to impart what she knows about paying attention to your materials. The mic does not need to mean anything, concretely, or to serve a conventional function. But there needs to be a reason for its presence in this space, with these people. It needs to be essential.

When I think of watching Parson's work over the past 12 years—built mostly for and with her company, Big Dance Theater, which she directs with Paul Lazar—I think of this emphasis on efficiency. Everything, whether a microphone or a fleeting folk dance, has its place, as if belonging to a natural order. Yet while "efficient" might suggest minimalist or spare, her aesthetic is not. There is so much stuff in Parson's onstage worlds: a glorious plethora of props, costumes, and scenic elements, imbued with lives of their own. There are just the essentials, yes, but the essentials abound.

This book, as I see it, is largely and loosely about that stuff and its sacredness, its worthiness of a closer look long after the curtain has gone down. What can a work's tangible surfaces tell us about its deeper, less visible layers? Let's take the props and costumes out of storage—the aprons, sticks, chairs, fur coats, wigs, guitars and parasols—and see what they reveal about an artist and her preoccupations. Let's consider the relationships between people and things: how the meaning we ascribe to objects depends on what we do with them; how we need them, and they need us. Parson reminds us that even within a medium as evanescent as

live performance, not everything disappears, and what remains brims with beauty and information.

Echoes and Duplications

A few months before this book's publication, I sit down with Parson to flip through a draft of its charts and scores. The project began, she tells me, with an invitation from the critic and poet Claudia La Rocco in 2011. As the dance editor of *The Brooklyn Rail* at the time, La Rocco asked a handful of choreographers to contribute to what she called an "On the Page dance festival." Her question to them, as articulated in her editor's note: "What does choreography look like on the page?" Parson recalls an even more succinct prompt: "Draw your dance."

Parson has always liked to draw—she was an art major in college before turning her focus to choreography—but she had never thought to illustrate her works. At the suggestion of the artist Suzanne Bocanegra, her friend and frequent collaborator, she set out to sketch the props and costumes stowed away in her basement. That exercise resulted in her first published dance chart, printed in the *Rail*'s July/August 2011 issue and straightforwardly titled "All the Props in My Basement."

This simple act of documentation turned out to be illuminating, bringing Parson's awareness to recurring imagery she hadn't noticed, at least not consciously.

Across the 12 works included in "All the Props," we find five pairs of slippers, two laurel wreaths, three crutches or canes, two folding fans, and multiple light-up items (logs, house, bonnet, tulips, desk) among other echoes and duplications.

Parson, who describes herself as "hyper-generative"—the kind of person who "makes things because they can't stop making things"—had stumbled into a new artistic practice, adjacent to the practice of creating live performance. Drawing allowed her to reflect on what she had made by making something new; developing each chart, finding the right structure, became its own kind of choreographic process. And so she continued putting colored pencil to paper, taking stock of her dances' material parts. In future charts, she would group objects not by the work in which they appeared but by type—corralling onto one page, for instance, all the logs, trees, and sticks across her body of work, an inventory of trunks and branches.

Regardless of what repeats, Parson is fascinated by repetition itself. What an artist (herself included) holds onto from piece to piece, and how that interest evolves with further research: These reiterations intrigue her more than what's different or new in a given work. In her 2015 pamphlet *Dance By Letter*, a choreographer's alphabet book, she writes: "O is for originality. The search for originality is motivating; the reality of it is questionable. The artist reshuffles,

uncovers, reconsiders, repairs, inverts, extends." In the space below, she has drawn five snowflakes of assorted shapes and sizes, an expression of variation within sameness. "R is for repetition, repetition, repetition," she writes a few pages later, invoking Gertrude Stein as she observes, "If you are really present, that which is repeated is always new."

I ask her about aprons, to which she has devoted a full page of this book. Why does she love them? Why does she return to them?

From a formal perspective, aprons are these wonderful rectangles that simply tie onto the body. And from a content perspective, they seem to evoke and awaken the past. They immediately bring up ideas around women,domesticity, all sorts of visual thoughts around class and station. Aprons also are an actual layering of fabric, which I love. And theatrically they can transform a performer immediately. Without needing to leave the stage, you can just take them on and off and indicate new personas.

What about sticks?

Mother Nature is so masterful. She is the greatest compositional artist! It fascinates me to bring a piece of nature like a stick or a branch onstage, and to choreograph them in this artificial setting. A stick can quickly move from a purely formal element to one replete with content—from a line in space to

a weight-bearing crutch, for instance, implying old age. A perfect example of how flexible materiality is.

And braids?

Braids are like codes. Also very female, transformational, complicated. There's a lot of emotion around them, having to do with phases of life. You see both little girls and old women wearing braids. You can braid with the body, too. It's a verb and a noun.

As Parson explains her attraction to these elemental things, her voice fills up with conviction and delight, the knowledge that she is onto something. Looking back on her work with these reflections in mind, I realize how much I've been missing. Swept up in the often rapid pace and dense layering of Big Dance Theater's productions, I've rarely paused to consider why a braid, or a branch, or an apron might be evocative, noting only that they are. Decoration, indeed, is underrated.

Animating the Inanimate

Critics and journalists, myself included, have often described Big Dance Theater as a "genre-blurring" company (the label you apply when no label applies). Among the genres we're referring to are dance, theater, music, and video; often these collide to relay a refracted, nonlinear narrative. You may wonder, in the course of watching a Big Dance Theater show: What is this? A contemporary play, a

Greek tragedy, a film adaptation, a dance piece, a musical? But to fixate on categories won't get you very far, so thoroughly does the work dissolve any boundaries between them.

While this blurring may register on a large scale—what to call the work as a whole?—it arises from an accumulation of small, precisely orchestrated moments, crafted with an exacting attention to how everyone and everything moves through space. Together with her collaborators, Parson choreographs not just dancers and actors but also costumes, props, and scenery, animating the inanimate. I think of the fish projected onto the side of a bucket in *The Other Here*— such that the bucket appears to hold a living fish—or the fan clasped between a dancer's toes, as she lifts her leg, in *The Snow Falls in the Winter.* As Parson's choreographic thinking suffuses every corner of the work, the work slips out from any box we might construct for it.

I'm not surprised when Parson tells me, "When I was little I always thought objects were alive. Dolls were alive, stuffed animals were alive. I'd leave my room and say to them, 'OK, don't move! I'll be back soon.'" Films like Disney's *Pinocchio* enthralled her for the endowing of everything—objects, animals, people—with a lifelike nature.

Years later, she hasn't ruled out the possibility of objects as sentient beings. "Maybe for me, the line between animate and inanimate is a little blurry," she says. "There is so much soul in some objects; they can hold so much resonance." In her theatrical scenarios, it often seems as if anything, at any time, could spring to life: an office chair, a shag rug, a telephone. And while consciousness might be a stretch, in her hands things can and do spring into motion, or reveal themselves to be sources of light and sound. Stealthily equipping the inanimate with microphones and light bulbs, she gives them voice and breath.

People and Things

One day I receive an email with the subject line "Objects and community." Parson has sent me a highlighted passage from *The Courage to Be Disliked,* a book based on the late 19th and early 20th-century theories of the Austrian psychologist Alfred Adler, published in 2017. The text unfolds as a dialogue between a young man and a philosopher. "Pretty far out!" she writes, by way of introducing this exchange:

PHILOSOPHER: When Adler refers to community, he goes beyond the household, school, workplace, and local society, and treats it as all-inclusive, covering not only nations and all of humanity but also the entire axis of time from the past to the future—and he includes plants and animals and even inanimate objects.

Far-out it may be, but Parson seems to operate from a similar understanding of

community, wide enough to encompass the inanimate. And why not? Objects are, after all, part of the fabric of our daily lives, across cultures, facilitating every basic ritual: eating, sleeping, walking, worship, celebration, getting dressed, to name a few. In an age of mass production, consumption, disposal, and waste, Parson's care and curiosity toward material things seems like a rare and vital kind of stewardship. This is not a precious or acquisitive attitude, but a fundamental decency, the kind of respect with which you would treat a neighbor or a friend.

Through her etchings and collages, Parson teases out the web of relations among our living, corporeal beings and the objects in our midst, honoring how we all move through the world together, interdependently. These relations might be purely formal. In "Chart of Things Circular" and "Chart of Things Rectangular," people and things inhabit the same plane, affiliated by shape. A dancer's arms raised in fifth position (curved to frame the face, fingers almost touching overhead) and a big round furry bag: These have circularity in common. As Parson puts it, "There's really no difference, at least in my brain, between a circle dance and a basketball. Both can be distilled to issues of circularity."

Parson looks at objects and sees aspects of the human body. She taps into channels that connect the two, allows them to collude. A chair, she writes, is "the pelvis of the inanimate world." (If you happen to be sitting in one right now, take a moment to note how true that is.) In the score "Chair as Pelvis," the facings of a chair, as she has drawn them, dictate the interpreter's orientation onstage, or which way the pelvis faces. Through this arrangement a person takes direction (literally) from a chair.

Objects hold little meaning apart from what we do with them. Parson reminds us, obliquely, that nouns need verbs. While most of this book's pages teem with images, a few are filled primarily with words. "Verb Score," for example, gives us a smattering of post-it notes scrawled with action words: to discard, to arrange, to bundle, to wrap, to crease, and so on. (Originally these served as a set of instructions for a duet between Mikhail Baryshnikov and Tymberly Canale.) The only object on the page is a gray folding table, drawn beside the verb "to fold." But in the context of this object-saturated book, we can't help but wonder what other nouns these verbs might activate. We might envision furniture arranged, firewood bundled, aprons creased: items from other pages flocking to this one in search of purpose. We might imagine people doing to the same, discovering ways to fold and wrap the body.

Here and elsewhere, Parson gives us space to imagine, much as she does in her works of live performance. It doesn't matter if you've seen the dances

documented in this book. Artworks in themselves, her drawings invite us to weave new stories of our own, to free-associate. What might be the relationship between a mustache, a crown, and a wheelchair (as found in the chart for *Supernatural Wife*)? How about a brief case, a bandage, and a gun *(Alan Smithee Directed This Play)*? Or a knife, white tape, and Twinkies *(Lazarus)*? In the spirit of her postmodern dance predecessors (Merce Cunningham, the Judson Dance Theater crew) Parson collapses hierarchies on the page, as she does on the stage; no word or image is more important than any other. Flowing in multiple directions at once, her charts and scores don't tell us how to read them. They give us points of reference and trust that we'll fill in the rest.

Against Disappearance, In Favor of Dance

Dance is known for disappearing, the most elusive art, the most difficult to notate and archive and reconstruct. "I hate the ephemerality of performance," Parson says. "When it's over, it's so gone." Drawing is a kind of rejoinder to that transience, her way of asking, "What's left? Maybe you could make something else from it before it completely disappears. Maybe the drawings constitute a kind of shadow life."

Parson often talks about how in ancient and medieval theater, people danced; dance was not some quirky outlier but integral to the world of a play. Yet at some point, at least in the West, the form lost touch with movement. Theater without dance, for Parson, is nearly unbearable, betraying a fear of the body and of "the things that dance owns— ambiguity, layer, mystery, abstraction, the non-narrative," as she has said. If one line sums up her mission as an artist, it might be what she once told the author Amy Fusselman: "[I]n my tiny corner, I have tried to resurrect dance in theater."

This book underscores how far-reaching and constant that mission is, extending not just to bodies moving through space, but to all tangible things. Even the book itself seems to bristle with motion, as words and images tumble across the page, or nestle into their given places, like performers finding their marks. Though the show might be over, the dancing continues here.

Siobhan Burke

References

Fusselman, Amy. *Idiophone.* Minneapolis: Coffee House Press, 2018.

Kishimi, Ichiro and Koga, Fumitake. *The Courage to Be Disliked: The Japanese Phenomenon That Shows You How to Change Your Life and Achieve Real Happiness.* New York: Atria Books, 2017.

La Rocco, Claudia. "Editor's Note." *The Brooklyn Rail,* July–August 2011.

Parson, Annie-B. "All the Props in My Basement." *The Brooklyn Rail,* July–August 2011.

Parson, Annie-B. *Dance By Letter.* New York: 53rd State Press, 2016.

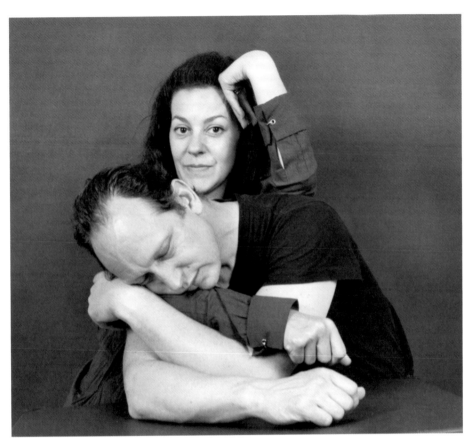

Annie-B Parson and Paul Lazar, 2003

Annie-B Parson is a choreographer. She co-founded Big Dance Theater in 1991 with Molly Hickok and Paul Lazar. Since then, Big Dance Theater has continuously created and performed their work nationally and internationally. Parson has also made choreography for opera, ballet, theater, symphony orchestras, string quartets, marching bands, rock shows, movies, museums, objects, television, augmented reality, and a chorus of 1,000 amateur singers.

Siobhan Burke writes on dance for The New York Times and other publications. She teaches at Barnard College.

Acknowledgments

Thank you to Claudia LaRocca, who first commissioned a drawing from me. As I remember, she asked me to: "Draw a dance." And to Suzanne Bocanegra who then suggested: "just draw all the stuff from your dances that you have stored in the basement."

Thank you to my son Jack Lazar for countless discussions about the drawings; Suzanna Tamminen for sage advice during our meetings in Stanford, Ct.; Tina Satter for generous help with editing; The MacDowell Arts Colony for time and space in the woods; to Sharon Gresh and Lina McGinn for their tremendous eye(s) and generosity in designing this book. And to Joanne Howard, Oana Botez, Pamela Tatge, Karinne Keithley Syers, Vivian Sming, Sara Pereira da Silva, Ilana Khanin—and especially to Paul Lazar.

Great gratitude and deep bows to the dancers who danced in these works including:

Jess Barbagallo
Tricia Brouk
Tymberly Canale
Stacy Dawson
Elizabeth DeMent
Chris Giarmo
Betsy Gregory
Molly Hickok
Cynthia Hopkins
Sonja Kostich
Paul Lazar
Jennie MaryTai Liu
Aaron Mattocks
Ryutaro Mishima
Brandi Norton
Omagbitse Omagbemi
Kourtney Rutherford
Tina Satter
Enrico Wey
Wendy Whelan

The deck of cards: Elements of Composition, is inspired by and a repurposing of, imagery from the Mexican Loteria deck of cards.

List of Works Pictured

Photography Credits

Image Credits

Wesleyan University Press
Middletown CT 06459

www.wesleyan.edu/wespress

Design: Standard Issue, Brooklyn NY

Published with the support of Big Dance Theater, Inc.

"Stuff" was previously published in
PAJ: A Journal of Performance and Art
(PAJ 119), May 2018.

Printed in China

Library of Congress Cataloging-in-Publication
Data available upon request

Paperback ISBN: 978-0-8195-7906-5

First Edition

5 4 3 2 1